Problem Solving
Simple Solutions for Stronger Paintings

By Timothy Rees

Illustrations by Brittany Nopar
Comics by Timothy Rees

Product of Studio Novo

Copyright © 2012 Timothy Rees
All rights reserved.
ISBN: 1480034827
ISBN-13: 978-1480034822

DEDICATION

This is dedicated to my students, who have taught me so much about teaching while challenging me to find answers.

"It took me **57 cups of coffee**, but I solved the problems of painting!"

CONTENTS

	Acknowledgements	7
	Introduction	9
Chapter 1	**Materials and Miscellaneous**	11
Chapter 2	**Problem Solving**	29
	I. Composition	31
	II. The Importance of Drawing	57
	III. Fixing the Drawing	68
	IV. Color	73
	V. Getting the Color	77
	VI. Photographs	79
	VII. Effective Studying	82
Chapter 3	**Assignments**	85
Appendix	**Introduction**	95
	I. Rendering Light vs. Form	96
	II. Color Mixing	100

III. The Problem of Light Sources	102
IV. Canvas Lighting	104
V. Painting up to the Illumination	106
VI. Reflected Light	108
VII. Lighting Effects on the Canvas	110
VIII. Light in the Shadows	111
IX. Varying Brush Stroke Sizes	114
X. Getting Good Brushwork	115
XI. Softening Edges	117
XII. Learning to See Things as Brushstrokes	120
XIII. The Dent Effect	122
XIV. The Dirt/Bruise Effect	123
XV. A Note About Historical Palettes	124
XVI. It's All About Relationships: The Hierarchy	125
Recommended Reading	132
Recommended Artists	134
Color Isolator Card	135
Index of Plates	136

ACKNOWLEDGEMENTS

A big thanks to a few artists who got the ball rolling for me: Bonnie, Mike, and Tracy. They accepted me into their painting group and showed me the way to the Palette and Chisel. Thanks also to Tony for his input on the revision of this book. My biggest gratitude goes to my fiancée, Brittany: editor, model of countless paintings, and best friend.

"Alright class, the painting on your left looks like the model, but Sam's painting on the right here makes me *feel her spirit.*"

INTRODUCTION

I have written what follows as a companion for those enrolled in a course taught by myself: "Problem Solving: Simple Solutions for Great Paintings". It is intended to be an overview of fundamental information, as well as an introduction to logical and straightforward information to strengthen method and create stronger paintings. The class was designed to introduce ideas in a logical procession, with in-class and at home assignments coordinated for the students to get the most benefit out of the class. This is not a "how to" book. There are many very good books on techniques currently in print describing various methods to approach a realistic painting, so this book is in turn focused on problem solving tools that can be applied to all of these styles. The majority of the information presented, unless otherwise noted, tends to be more empirical than suggestive. Many of them are tips and tools not presented in art schools, discovered through countless hours of work, talking with other artists, and observing fellow artists working in a community setting.

Because the text is stripped of the theoretical, emotional aspect of art, the content is in turn more information based. It is most likely too much information for one to absorb the first time through, and in class I try to encourage students to absorb 10-20%, then come back for more once that knowledge is mastered.

The first class session involves a lengthy discussion concerning the impact of materials [pp. 11-24], methods to create more dynamic compositions [pp. 31-56], and problem solving tools associated with drawing [pp. 57-72]. This is followed by a quick demonstration of a black and white painting, allowing the students to observe paint application in a "direct" or "wet into wet" style of painting. The first class is followed by the at home assignment #1 [pp. 86-87] to challenge the students to think more about compositional design with use of darks and lights.

The second session has the students setting up and painting a black and white still life following a review of the homework sketches. The students become more familiar with paint handling and have the opportunity to practice the problem solving techniques associated with drawing without the distraction of color. The class ends with a lecture on the properties of oil paint [pp. 25-28] and problem solving tools associated with color [pp. 73-78]. The at home assignment #2 [pp. 88-89] has students working to see and simplify color as well as work on

composition.

The third session has the students set up and work on a color still life. The same compositional design elements are used, but this time the students must work in color. The problem solving techniques associated with color are reinforced, and the students practice these in addition to the drawing problem solving. Assignment #3 [pp. 90-91] has students simplifying a portrait drawing or photo to a few obvious shapes. This helps the students learn how to break down complex structures into organized shapes to build a painting upon.

Class sessions four and five have the students painting a portrait, again using all of the problem solving techniques presented. The fourth assignment [pp. 92-93] (done after session four) helps the students to see how a master may handle a similar situation. The fifth assignment [p. 94] encourages the students to be active in their studies, completing compositional sketches from admired works in an attempt to assimilate the strengths of these works into their own.

With this expanded edition comes more illustrations to bring greater clarity to the ideas, in the hopes that those who have not taken the class will make more sense of the text without demonstrations. I have also added an appendix at the end of the book. This contains a slightly more eclectic collection of problem solving tools and tips that can be applied practically to one's studio working methods. I have also included several outside resources and references to aid in further personal growth.

Chapter 1

Materials and Miscellaneous

Some may not realize, but the materials one uses have a large impact in the handling of paint and the look of paintings. By knowing how and why certain materials are used, a more appropriate choice can be made to get desired results. Issues such as the flatness of the values, appearance of brush strokes, saturation of color, and more can all be influenced or determined by materials.

Also, the length of time a work will last depends greatly on the type of materials used. Some materials will allow a painting to last five centuries, while others may make it fall apart in a year. Knowing where to invest the money and time into appropriate materials is essential for anyone entering the field, hobbyist or professional.

One of my biggest challenges in teaching has been the struggle with the issues of materials. Many beginners or amateurs do not realize their importance. Of course, I cannot blame those without experience for not knowing. Walking into any art or craft store, one is bombarded with low quality materials that will, for the most part, only hinder your goals as an artist (i.e. achieving the look you set out to achieve). Without a guide to inform selection, it is quite possible to waste literally hundreds of dollars on supplies that may ultimately go unused. As such, my frustration does not stand with a student's lack of knowledge. It comes when I inform students which supplies are superior and why, and I tell them how to obtain them for equal cost or less, and they continue to use inferior materials. Usually by the end of five weeks of painting and hours of struggling, the importance of materials becomes realized.

As such, the first section of this book will serve as this guide. Take special note to review the various pages on priming, substrates, brushes, and paint to ensure you can master these fundamentals of problem solving.

The Problem of Primers

Every surface that is to be painted on must be primed (or sized and then primed). The primer is a layer that the paint can adhere to, and sizing is a layer that prevents the primer and paint from touching the substrate. If one were to paint directly on a substrate without priming, such as paper or fabric, there is risk that the oils from the paint could cause the substrate to rot. Priming also acts to even out the painting surface from any irregularities of the substrate, and to provide an even tone (usually a bright white), which becomes important for the vibrancy of the painting over time. Beyond these important fundamentals, priming can greatly affect how correctable an oil painting is, how quickly it dries, how rich the colors are, and more.

Acrylic. The more recently developed primer (created in the mid 1900's) is acrylic, commonly referred to as gesso. Acrylic, a synthetic substance, dries as a film resembling plastic, and can support a variety of materials, including acrylic, alkyd, and oil paints. It also typically acts as a size, creating a barrier to the substrate and a support in one. This versatility, combined with its quick drying nature and lower cost, has lead to its popularity and wide use on most substrates available in art or craft supply stores.

Unfortunately, acrylic is a less preferred support for oil painters. It is more likely to be stained, making it difficult to rework paint or correct mistakes, and it is impossible to return to the white of the canvas. Some of the vibrancy of the colors or richness of the darks can be lost. The drying time of the oil paint will be accelerated (which may be preferred by some), a side effect of its more absorbent qualities.

Oil. The traditional primer of oil paintings for centuries has been oil. It is more difficult to apply, more expensive, and has the potential to be toxic with extended exposure. Its compatibility is also limited to oil paint. Because oil primer can cause the substrate to rot, a coat of sizing is required prior to application. For these reasons, it is more difficult to find oil-primed surfaces in the majority of art supply stores, and impossible to find them in craft stores carrying art supplies.

Despite these challenges, the benefits of oil-primed surfaces overshadow alternative choices. The painting becomes more forgiving, allowing the artist to rework and correct mistakes. If the oil priming is applied well, entire passages of a painting can be lifted off the next day to be reworked freshly. This is largely because oil priming is less susceptible to staining, allowing the oil paint to sit directly on top of the primer. This also allows for more vibrant colors, as the light will pass through the oil paint, hit the surface of the canvas, and reflect to the viewer. For paint that looks *juicy, rich, and freshly applied*, oil-primed surfaces are instrumental. Because of this lack of absorption, the artist has greater control over the look of the brush strokes as well. The presence of individual hair strokes can be retained (*fig 1*), or blended and softened. Depending on the style and size of one's painting, this can become very advantageous (usually smaller paintings requiring more detail will demand a more delicate appearance of brush work). Surfaces that can be stained, such as acrylic-primed surfaces, will have a certain amount of dispersion of paint, at best causing things to appear slightly out of focus, at worst having uneven distribution and expansion (the look of coffee spilled on a napkin). This softness must then be compensated for by the addition of numerous layers of oil paint.

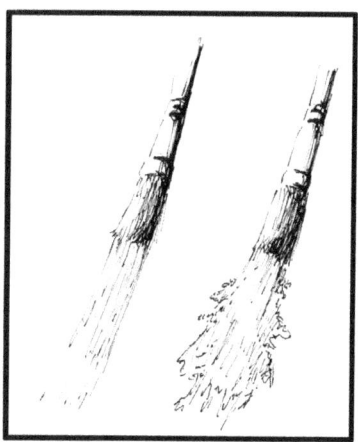

Fig 1. Brush stroke on oil-primed surface (left) retains shape, while brush stroke on acrylic primed surface (right) may disperse

Also with oil priming comes its historical track record. While paintings completed on acrylic ground have lasted a few decades (with the possibility of many more to come), paintings completed on oil primer have been proven to last for centuries.

Most modern oil primers available in stores are tagged as "oil painting" primers, with alkyd added to the recipe. These oil painting primers are much easier to use and less toxic than traditional lead oil primers. Alkyd speeds drying time, creating a workable painting surface within a day or week, as opposed to several. Alkyd is derived from alcohol and fatty acids (of a plant, such as linseed). This fact, combined with its relatively new introduction to the art supply world, causes some artists to express caution with its use.

CHECK OUT THESE ADDITIONAL RESOURCES!

- "The Artist's Handbook" by Ralph Mayer goes into depth about primers, as well as how to prime surfaces.
- www.amien.org has information on priming from a conservator's point of view.
- *Any art supply company* – should have sufficient information on properties, uses, and information on how to apply its primers. If it is not forthcoming with this information, it is safe to assume you should not use the product.

Substrates

There are many different substrates, or surfaces, to paint on that can lead to different appearances of paint, luminosity, and brush strokes, as well as affect the length of time the paint takes to dry and how long a painting can survive. Some surfaces are more portable than others, and some are more durable. In the end, selecting a surface will become highly based on personal preference, as there is no "right one." Knowing a few of the basic strengths and weaknesses can help you make a selection that's right for you. What follows are a few of the more readily available and common substrates.

"Aren't you supposed to wait for them to turn the plant into a substrate before you paint on it?"

Cotton. Cotton, or "cotton duck" as it is also known, is made (as it suggests) from the woven fibers of the cotton plant. The fibers will feel softer than other painting surface fibers, and it tends to be more absorbent. It is a newer substrate (compared to linen and wood) and has not been proven to last as long. Manufactures typically suggest its lifespan to range from one to two hundred years. It can vary in smoothness depending on the tightness of the weave, though in most prepared cotton canvas available for sale the fibers are not pulled tight enough to reach the very smooth end of the spectrum. Cotton is also less expensive to produce and is the most economical of painting surfaces. Because of this, it is the most common painting surface available in art or craft stores. Properly sized and primed, however, pleasing results can be achieved. Most pre-primed cotton will not be oil primed, however, so if just oil priming is desired (without the use of acrylic size/gesso) it is best to prepare raw canvas.

"I still don't get it... how do they turn ducks into canvas?"

Linen. Linen is derived from the flax plant (*fig 2*), which produces stronger fibers than cotton. It generally lends itself to be less absorbent (especially when primed with oil primer). Because of the strength of the fiber, it can be woven very tightly, producing a tough cloth that can be rough, smooth, heavy, or light. The life span of linen will easily reach two to five hundred years, assuming proper care. It is considered more durable than cotton, and is usually the preferred cloth substrate for oil painters. An advantage of cloth substrates such as linen and cotton is that paintings or unused material can be rolled for easier, lighter transportation and storage. If a completed painting is to be rolled (assuming it is completely dried), an attempt should be made to minimize the amount of time in rolled form, as it puts unnatural stress on the paint film. Generally one should roll the painting no longer than the time required to ship, then have it unrolled and mounted or stretched. Be certain to roll the canvas with the largest diameter possible to avoid unnecessary stress. Paintings rolled too tightly or before completely dried (4-12 months) run the risk of cracking. These cracks may show up immediately or after several years.

Wood. Although one might think wood to deteriorate or rot, some of the longest lasting masterpieces were crafted on properly primed and maintained wood. Provided the wood has no adverse chemical additives and is kept in an appropriate level of humidity, it has large archival potential. The surface is generally texture-free and very smooth, but this can be adjusted if texture is brushed into the primer. On a smooth primed wood panel, strokes can look slick, and subtle blending can be achieved.

Fig 2. *Flax Plant*, source of linen and linseed oil

Wood panels are more bulky and heavy to transport, but not prone to tearing. Paintings intended to be exposed, stored, or displayed in areas subject to excessive temperature or humidity change should be sealed on the sides and back to minimize warping or rotting of the wood. This can be done with a strong, weather resistant coating such as polyurethane.

"Hey, your painting looks great! Lets grab some lunch."

"Hmm, a bit bent…. Maybe call it modern art?"

Wood Composite. A close relative of wooden panels are wood composite substrates, such as hardboard (sometime called by the brand name Masonite). These are often thinner and sometimes lighter and cheaper than wood, and come in a variety of finishes and colors. It is important to remember, though, when opting for hardboard, that they are usually filled with and/or covered with unidentifiable additives and glues (formaldehyde, which can damage a painting, is a common example of this). These chemicals, which can be more or less acidic, hold the fibers together to make the board. There is potential for them to eat away at the sizing and into the painting, or increase the chance of SID*. Because of this, it is best to resist the temptation of buying cheap hardboard (such as those from the hardware store), and opt for artist quality hardboard that is forthright with its chemical content, such as Ampersand. These hardboard panels are often less prone to warping, more moisture resistant, and are ready to accept primer.

*SID- Support Induced Discoloration. When improper sizing, chemical-covered, or non-PH balanced support causes the color of the support to soak through and alter the color of the painting, either in isolated spots or the entire surface.

Mounting/Stretching/Taping. If one desires the qualities of linen but rigidity of wood, it may be beneficial to mount canvas onto wood or boards. When doing so, make certain to use a PH balanced adhesive that can bond fabric to wood, such as a good book-binding glue *(fig 3)*. Having many panels on hand can be useful, especially for outdoor painting, as they are more durable than stretched canvas and more compact when traveling. For larger paintings, linen supported by a braced panel is preferred to stretcher bars for longevity, as less movement of the canvas surface minimizes potentials for cracks. If the wood or board support ever begins to deteriorate, it is possible to remove the linen from the support and have it reapplied. Someone experienced with restoration should execute this procedure, and knowledge about the adhesive used in mounting is helpful.

Fig 3. *Anatomy of a mounted canvas panel*: (from left to right) Panel, SID Barrier, Glue, Canvas, Size, Primer

When one desires a more flexible surface that has some spring, stretching is more appropriate *(fig 4)*. It is also beneficial when space becomes an issue, as it is very easy to remove old paintings from bars, store or dispose of them, and reuse the bars without the help of a conservator. This can make stretched canvas more cost effective than panels. It has become a common practice to tape a piece of primed canvas to a board to execute a painting, throwing it out if the results are unfavorable and stretching or mounting if it is a success. It can create problems with glare on the painting surface due to uneven, untightened canvas, but many artists have great success working in this manner. It is cost effective, but the same caution must be taken in selecting a tape that has acid-free adhesive to prevent damage to the canvas. Care must also be taken to stretch or mount the final piece so as not to disrupt the paint film.

Fig 4. *Anatomy of a stretched canvas*: (from left to right) Stretcher Bars, Canvas, Size, Primer

CHECK OUT THESE ADDITIONAL RESOURCES!

- www.amien.org has large amounts of information and forum discussions on substrates and their durability potential, as well as information on preparing mounted canvas.

Brushes

There are a vast array of brushes, both in shape and paint bearing qualities. It is important to know the capabilities of each type of brush in order to produce the desired effects and styles of paintings, although it is not necessary to keep every type on hand for a painting. Once mastery of a brush is obtained, a painting can be successfully executed with just a few.

Styles

Rounds- These brushes have a round body at the base and come to a point, and are best used for fine work that requires points or lines.

Flats- Resembles a chisel, with the tip coming to a thin flat edge. This is traditionally used for glazing colors or applying broad strokes. Conversely, the edge can be used to produce thin strokes. If marks are left, they can appear square or chiseled.

Filberts- Narrow and broad with a rounded edge. This will produce wide strokes with the ability to make a tapered edge.

Fans- Usually used for blending paint already applied to the canvas, not for applying paint.

Hair Length. Brush manufacturing companies can vary the length of the hair within each model, which can alter the brush's effectiveness with different styles of paint application. Shorter hairs limit the amount of paint load, but cause the hairs to be sturdier, often beneficial for scumbling or drawing. Long hair, alternately, can make the brush more flexible, useful for creating a variety of edges. It is important to note the variety of strokes made due to hair length.

Natural versus Synthetic. Natural hairs have been used for hundreds of years. They are pulled directly from the hide (not cut or shorn) to preserve the root of the hair, where the majority of the strength and spring derive. The hairs come in a variety of firmness, the most firm being bristle and the least firm being sable. Some natural hair brushes can last for years if properly cared for.

"So... am I just supposed to dip them in paint or what?"

Bristle. These hairs are generally pulled from a hog, and are typically the stiffest available. They have a tight springboard quality and are good at holding large amounts of paint to transfer to the canvas. Because of their firm nature, works painted with bristles will often show brush strokes or have a quality of impasto. A quality bristle brush can also produce delicate glazes if the paint load is limited.

Mongoose. These hairs fall in the middle range of flexibility. They are firm enough to produce a satisfying flick or spring, but the tips are soft enough to create subtle blended

edges. The fibers are not as thick as bristle and may not as easily hold large amounts of paint. It may be worth noting that hairs for these brushes originate from the Indian Mongoose, which is now an endangered species. Some companies have created a version of synthetic mongoose, all the while continuing to perfect its replica.

Sable. This hair is the softest of the oil painting brushes, and is more common in watercolor. It has less spring and is used primarily for details, blending, and fine line work. There is less chance of leaving brush marks when employing a sable. Paint load is also very limited.

Synthetic brushes have not been in production as long as natural brushes, and while the last 20 years has seen the development of fibers with fantastic properties, they still do not yet duplicate the full (and some would say satisfying) range of natural hairs. Because they are made from cut fibers that have been manufactured, they do not mimic the non-uniform natural hair (which varies in flexibility from the root to the tip). Most companies will, however, advertise which natural hair the synthetic is replacing, allowing for a more educated decision. As a general note, good quality synthetics will last longer than natural hairs, as the fibers are more durable. Once familiar with how they handle, many artists have had great success with synthetic.

Cleaning. It is best to have the best brushes you can afford (that you enjoy using). More expensive brushes typically have better quality hair with more even distribution, and more attention is paid to how they are bound and attached to limit hair loss. You will find it less expensive in the end to take care of a better quality brush than to neglect an inexpensive one. While washing with soap is only needed once or twice a week (with constant use), a brush cleaner with an artist grade paint thinner should be at hand for daily cleaning.

To wash, take soap and warm water and gently scrub the brush into the palm of your hand to build up a lather. Avoid hot water, as this will wear at the glue binding the hairs. Rinse and repeat until the suds are white and free of the oil color. A mild degreasing soap can be used, but it is most effective to use specific brush soap, such as "The Master's Brush Cleaner," which has been designed specifically to care for and restore brush hairs. Squeeze

the excess water from the bristles, and reshape the tip of the brush while damp to preserve the shape. It may be worth noting that some artists wash their brushes with soap after each use to minimize exposure to paint thinners, though this is a personal preference.

In between cleaning brushes with soap, it is wise to get a tin brush cleaner (which is filled with a paint thinner such as an odorless mineral spirit or brush cleaning fluid). After wiping off excess paint with a paper towel, gently stroke the brush along the grated bottom and sides of the cleaner. Wipe the remaining cleaner off the brush with a paper towel. Prolonged exposure to paint thinners will harm the hair so never let your brushes soak in the brush cleaner.

TIPS***
- Don't soak your brushes in mineral spirits (or Turpenoid). This will break down the strength of the hair fibers and dissolve the glue holding them onto the brush, causing them to fall out.
- To perfectly reshape a flat brush, fold a card over the edge of the hairs and clamp it with clothes pins or a strong clip. This will help achieve a perfect chiseled edge.

CHECK OUT THESE ADDITIONAL RESOURCES!

- "The Artist's Handbook" by Ralph Mayer
- "The Painter in Oil" by Daniel Parkhurst
- www.amien.org

What is Oil Paint?

Oil paint is not simply beautiful little puddles of mud, as some might have you think. Understanding *what* oil paint is can give us a better understanding of why it behaves as it does, and can allow us to produce desired effects.

Pigment. Pigment is the actual color. In its basic ground up form it resembles a colored powder. The various colors originate in many different places. The "earth" colors, for example, often come from colored earth (umber, for example, was a dirt pulled from the Italian town Umbria). Deriving from different sources, each color has its own unique chemical composition.

Pigment particles are randomly shaped and oriented, which allows light to bounce around the pigment and reflect as a pile of glowing color as opposed to a reflected beam of light. Each pigment has a different *index of refraction*. This determines how much light is allowed to pass through the particles and how much light is reflected back. The closer the index is to 1 (about the index of air), the more transparent the pigment is. Conversely, pigments with higher refraction are more opaque, or solid.

Higher index of refraction= more reflection= more opacity
Lower index of refraction= less reflection= more transparency. *(fig 5)*

"Let me get this straight, they use pigs to make brushes, but dirt to make *pig*ment?"

Each pigment absorbs a specific portion of the light spectrum, reflecting back the portion we perceive to be its color. Pure white reflects back all areas of the light spectrum, and as such is the brightest color available to artists.

Glazing with transparent colors can create brilliantly bright paintings, as more light is allowed to pass through the pigment and hit the white ground of a canvas, reflecting back with more intensity.

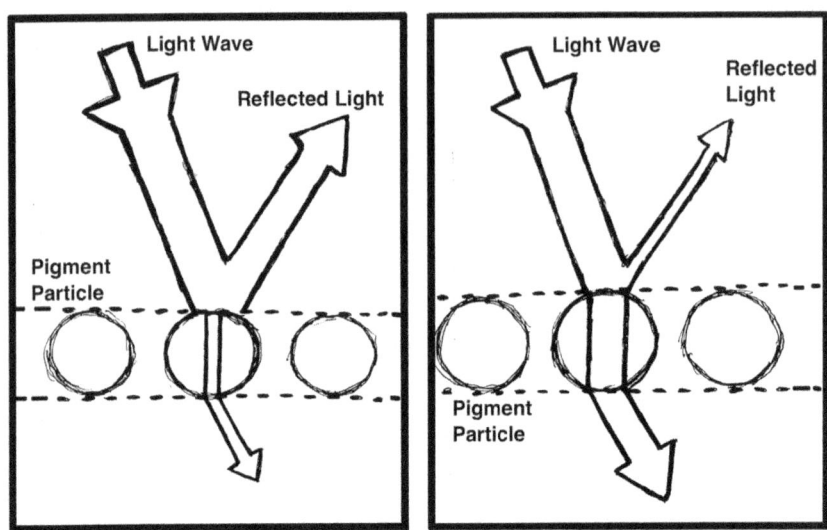

Fig 5. (*left*) Opaque pigment, with higher *index of refraction*, reflecting more light. (*right*) Transparent pigment, with lower *index of refraction*, reflecting less light.

Suspension. This is where the "oil" comes in. Each paint brand is different in the quality, color, and vibrancy of the pigment used as well as the suspension in which that pigment is placed. All use some type of oil, be it linseed, sunflower, walnut, or an unidentified

"secret oil," and are sometimes mixed with substances to modify its smoothness or consistency (such as beeswax or alkyd). Because suspension is less expensive than pigment, lower quality or student grade quality paints will contain a lower concentration of pigment and more oil, coming out of the tube runny or with less saturation, while higher quality paints will have more pigment and less oil, feeling much thicker out of the tube. This allows the artist to add oil to achieve a desired consistency. Depending on the type of suspension used, a paint can behave (and dry) in different ways, from being more transparent to drying flat, taking weeks to dry to the touch or just days.

Transparency and opacity can also be affected by the amount of suspension it is resting in. If a glaze of an opaque color is desired, adding medium can spread the pigment particles apart allowing for a look of transparency (*fig 6*).

When Colors Mix. When one color mixes with another it produces a distinctly different third color, or so it would seem. In actuality, no chemical reaction is taking place, and because of this, each of the original pigment retains their unique properties. Particles sit next to, on top of, and all around each other. Due to this intense co-existence of pigments, light that is reflected off the new pile of paint is sent to our eyes and simplified into one apparently blended, new color. This is important to note because the more different pigments mixed together, the smaller the portion of the light spectrum reflected back. This is why excessive mixing of pigments creates "muddier" colors. A mixed orange will never be as intense as pure cadmium orange, for example. To achieve vibrant, rich colors, strive to achieve your desired color with the most direct mixing possible.

Fig 6. (*top*) Opaque pigment reflecting light. (*bottom*) Opaque pigment made transparent with the addition of suspension.

Cheaper or student grade colors bearing "Hue" in their names are not a single pigment in suspension, but a blend of pigments made to imitate a pure color. Because of this, hues will not produce as clean and vibrant mixtures.

"I don't understand. I've used tube after tube of this student grade paint, but can't seem to get enough color."

Chapter 2
Problem Solving

All painting is a problem– the problem of putting the artist's view of a 3-dimensional world into everyone's view of a 2-dimensional canvas. What follows is a breakdown of fundamental elements of painting that can (and often should) be isolated to discern their correctness, and how to do just that.

This section concludes with a discussion of photographs and some tips to use them appropriately (as well as what to avoid), and a section on how to appropriately study to gain the most progress from art all around. Every artist is a student, and the learning process will never end.

"I don't think this was the kind of balance the teacher was talking about…."

Problem Solving I
COMPOSITION

A painting's composition can often be overlooked as a problem until much later into its execution. More so than any other aspect, this should be addressed early, before any hint of a problem becomes apparent. The more clear the idea, the more confident the approach can become. Good composition isn't a random occurrence. While it is often inspired by observation, many additional factors– subtraction, addition, cropping, moving, etc.– are often required to produce a composition with the most impact. Aspects of this section are more easily applied to painting a subject from life, but the principles should be carried over to works composed from imagination.

Look at your subject. A model or setting can seem so appealing that one might wish to jump right in and throw paint down on the canvas, but it is important to first study the subject. Look at it for several minutes and envision it on the canvas. Squint down and look again. You aren't wasting time if you're stopping problems before they happen. Certain elements, under various lighting conditions, may look strange. A face turned away under direct light may look like an unusual blob, for instance. The position of a hand might make it look deformed. Adjust for these issues in the beginning, changing the model as needed, moving your canvas around, or deciding which elements to omit or move. If you squint down and the entire set up looks unclear or awkward, move something around. If you need to, do a little sketch first. The longer you spend planning your compositions in the beginning, the stronger it will be, and the easier to execute the work with confidence. Being certain of your design and approach requires practice, but the experience gained is worth the extra effort.

Balance the image. Balance in a scene may not be apparent at first, but through shifting the placement on a canvas, omitting some aspects, or adding others, the artist has the power to achieve it. One simple way is to "think opposites."

What follows are reproductions of my work, provided with small compositional skeches, to illustrate specific ideas. All works are in oil, unless otherwise noted.

Fig 7. Small shapes on one side of the canvas will balance larger shapes on the other side. This is known as a weight counter weight design.

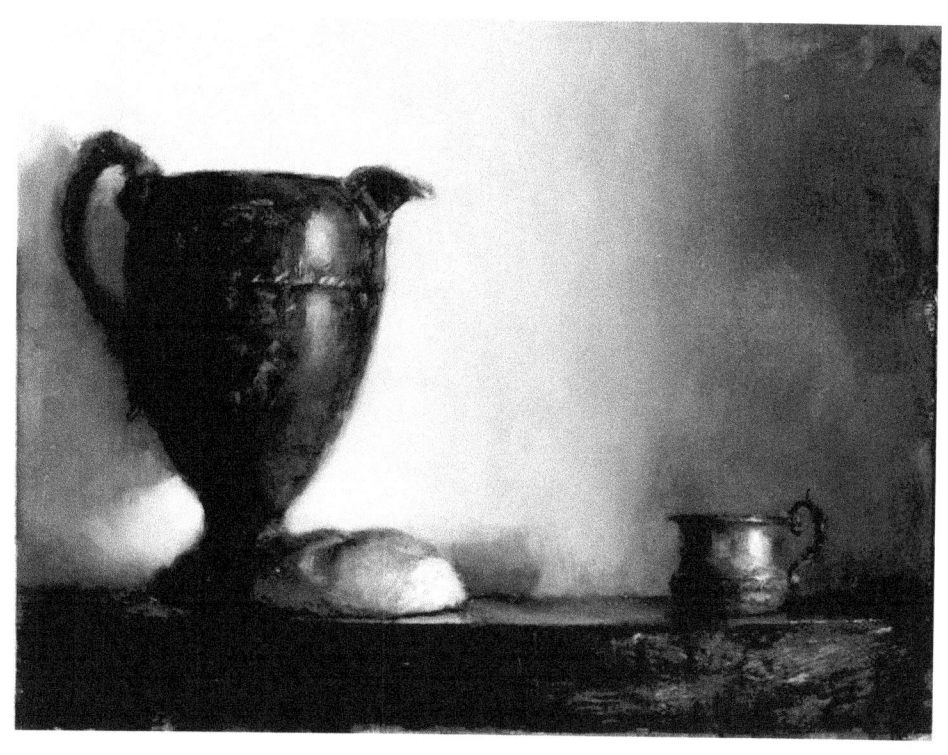

Plate I. *The Roman Breakfast*, 16x12"

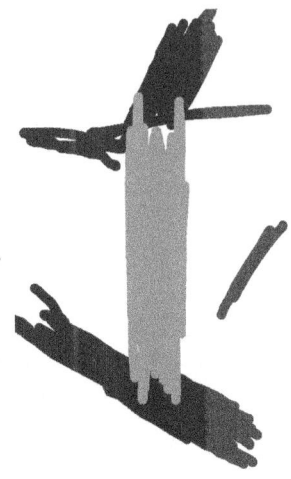

Fig 8. Horizontal and vertical lines balance diagonals

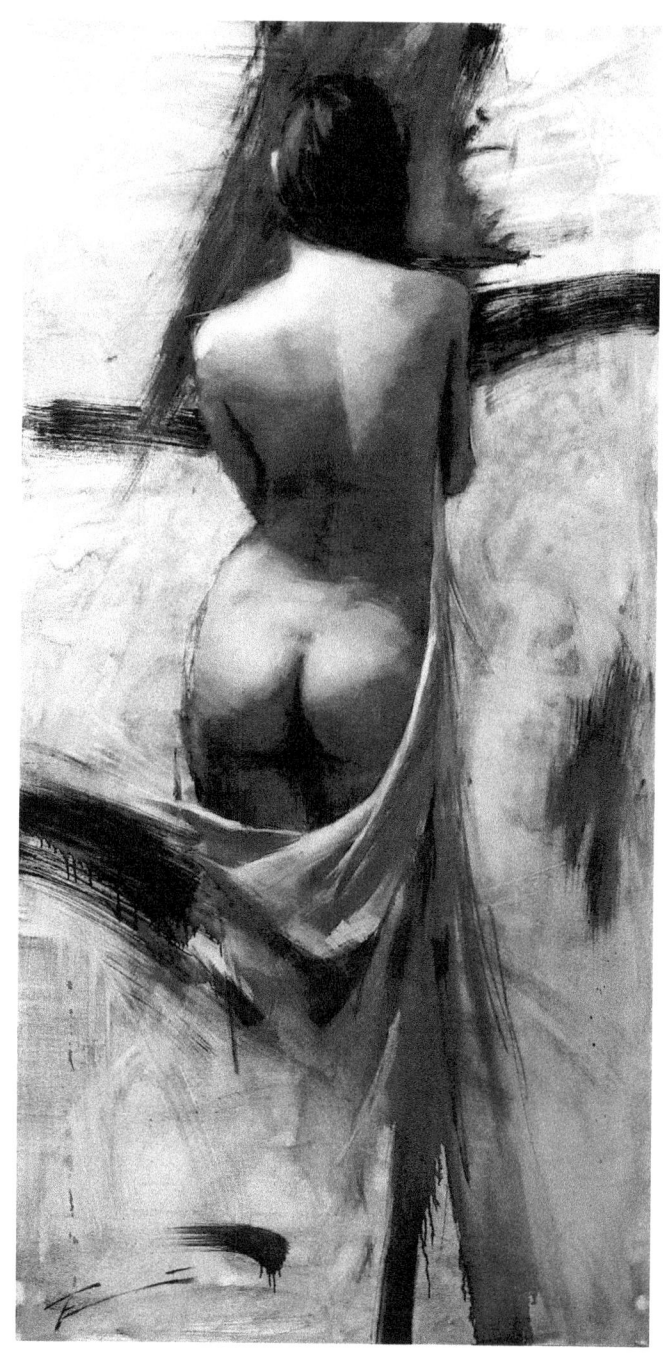

Plate II. *Phoenix Rising*, 72x36"

Fig 9. Light balances dark

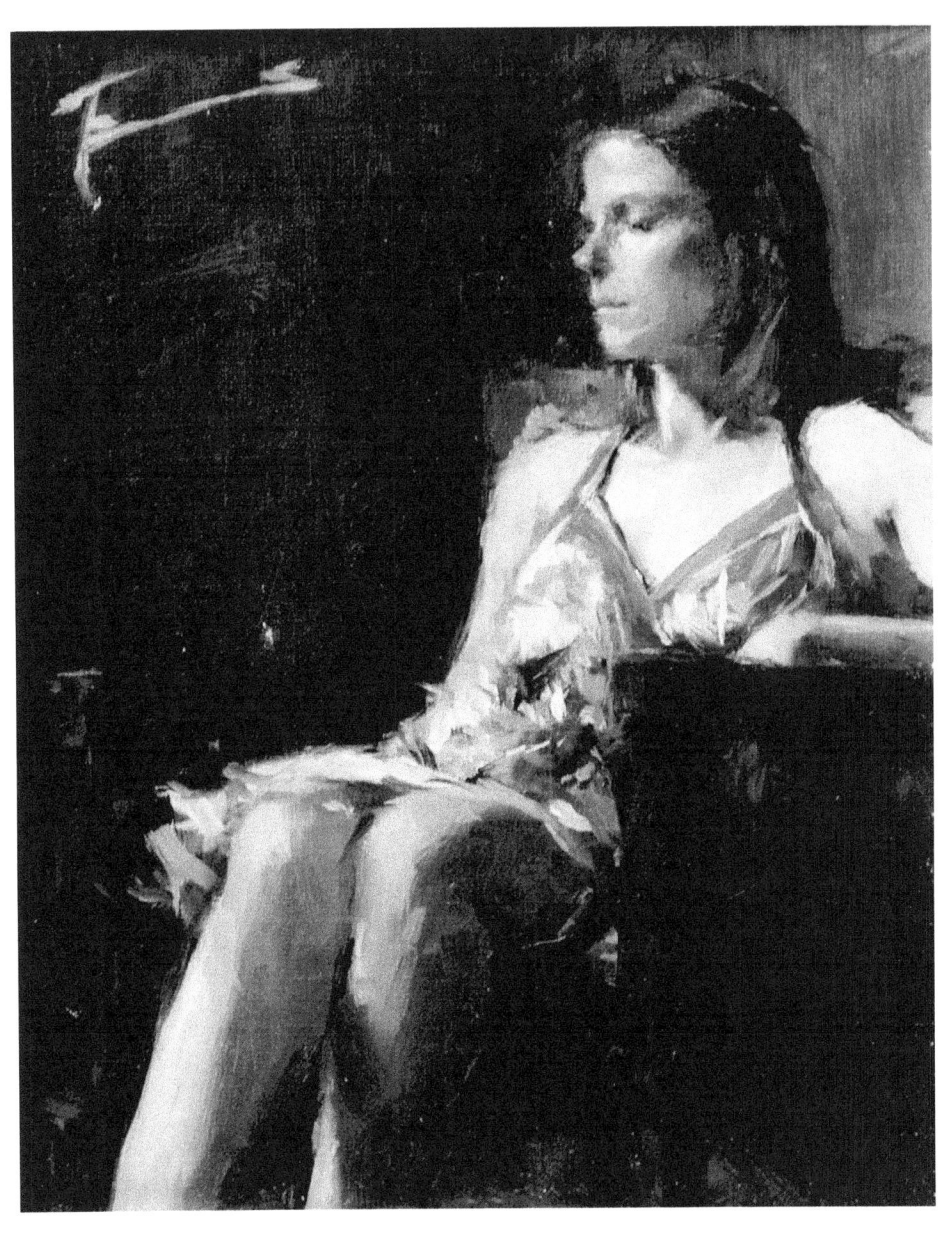

Plate III. *Her Blue Flowers*, 10x8"

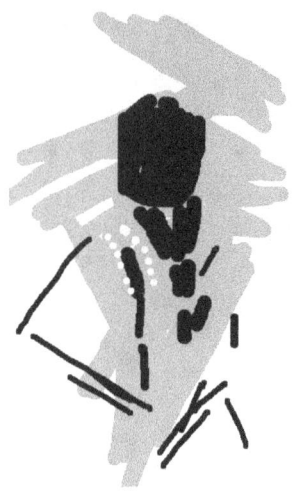

Fig 10. Even brushwork should be balanced. Contrast large brush strokes with small, thick paint application with thin. The human eye is naturally accustomed to seeing vast amounts of variety in nature, and the brain works to reduce it and be digestible without any effort. By maintaining variety one can achieve balance.

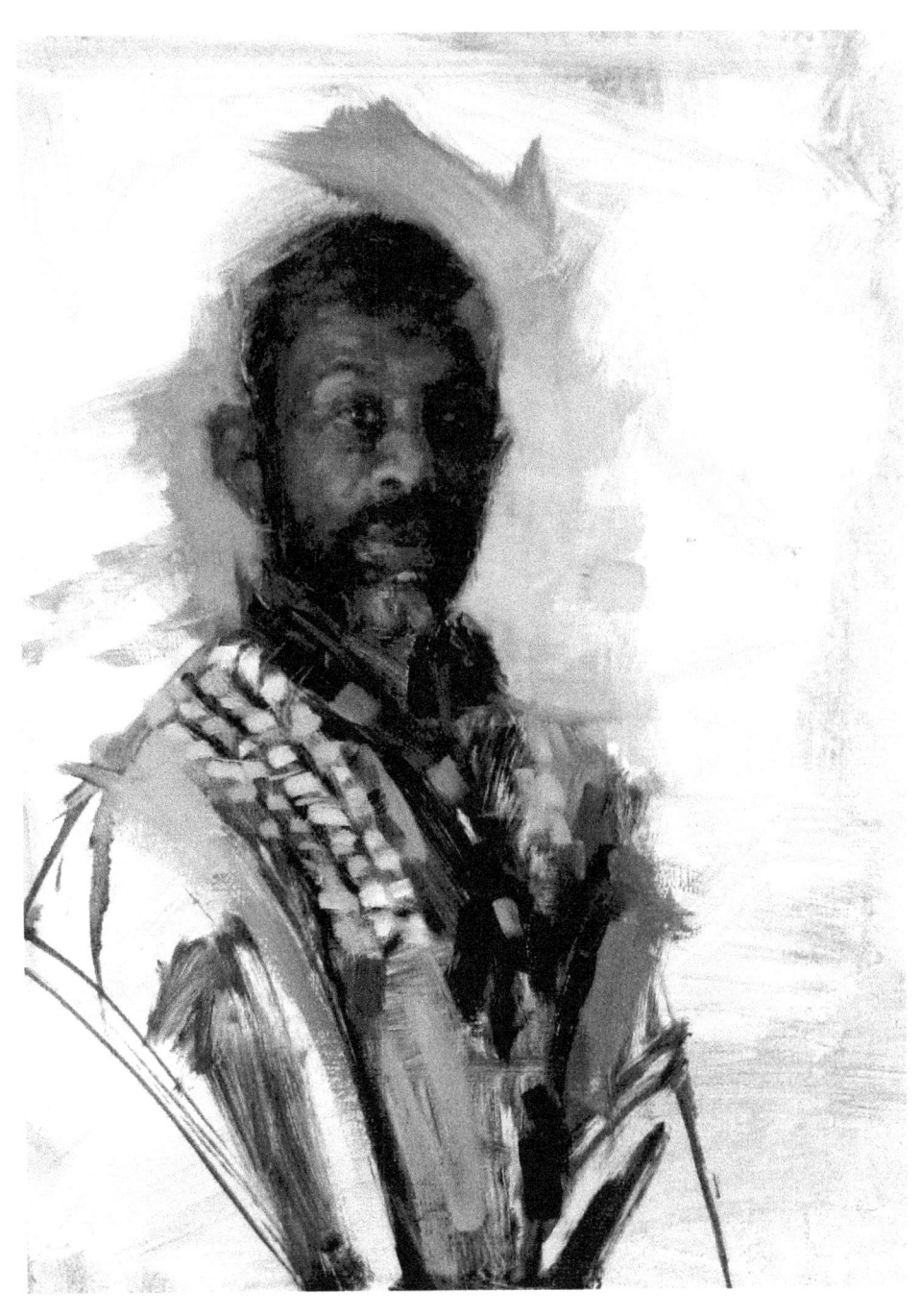

Plate IV. *The Great Gera*, 16x12 "

Fig 11. Line carries great weight, so its implementation, even when not perceived in a subject, can create balance.

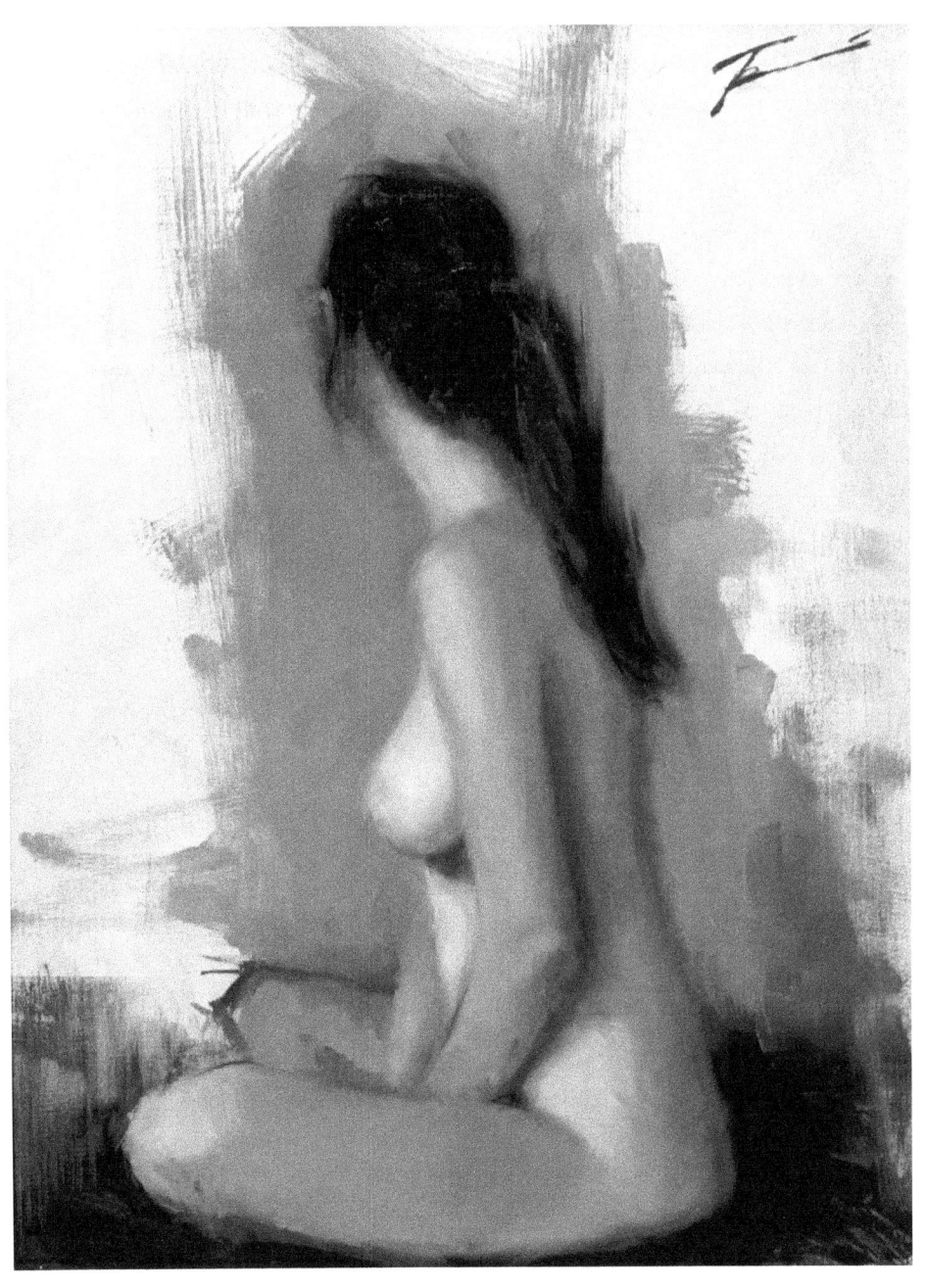

Plate V. *Seated Model*, 16x12"

Balance is all around us, and there are countless ways to achieve it. Another example is large amounts of neutral colors balancing areas of intense saturation. Observe nature, and study paintings. If a painting feels poorly weighted and uneasy, it is likely unbalanced. Look for paintings that feel sturdy and attempt to incorporate these ideas into your own.

Create Movement. Movement in a painting keeps the work interesting, and can guide the viewer to an intended direction. This keeps the piece more engaging and helps to hold longer interest. When deciding what about the subject is most interesting, think of what design or method can be employed to highlight and lead the viewer through. Some simple, effective means are balance, line, detail, value, color saturation, and paint application. Not all of these techniques can be employed every time, but by selecting the most apparent few and applying them, a piece can have very exciting movement.

"I guess that's one way to create movement in a painting."

Fig 12. *Use of Diagonals*. Personally, I'm a huge fan of diagonals. Whether a diagonal shape is painted or an invisible one is created by negative space between two shapes, diagonals increase the excitement of a painting.

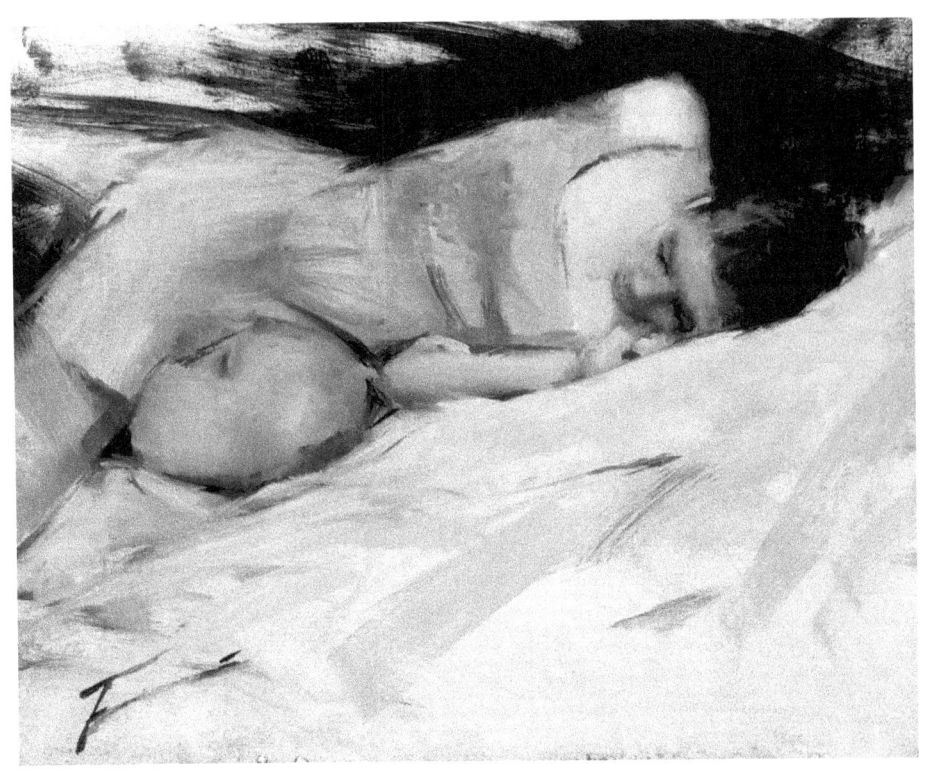

Plate VI. *The Orange Dress*, 8x10"

Fig 13. *Balance of Mass*. Not only used for making a painting feel stable, contrasting elements placed appropriately will naturally guide the eye from one spot to the next, ensuring the space between is not negated.

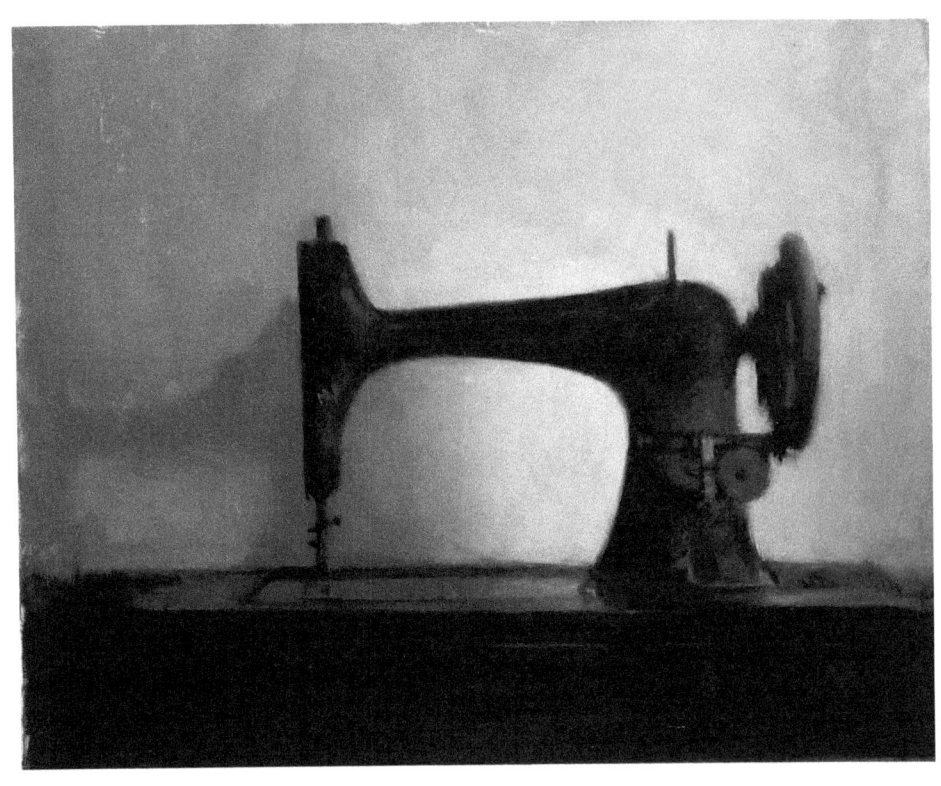

Plate VII. *The Chicago Sewing Machine,* 16x20"

Fig 14. *Line*. The human eye naturally follows any line in front of it. The sharper and more bold the line, the more attention and directional movement it will achieve.

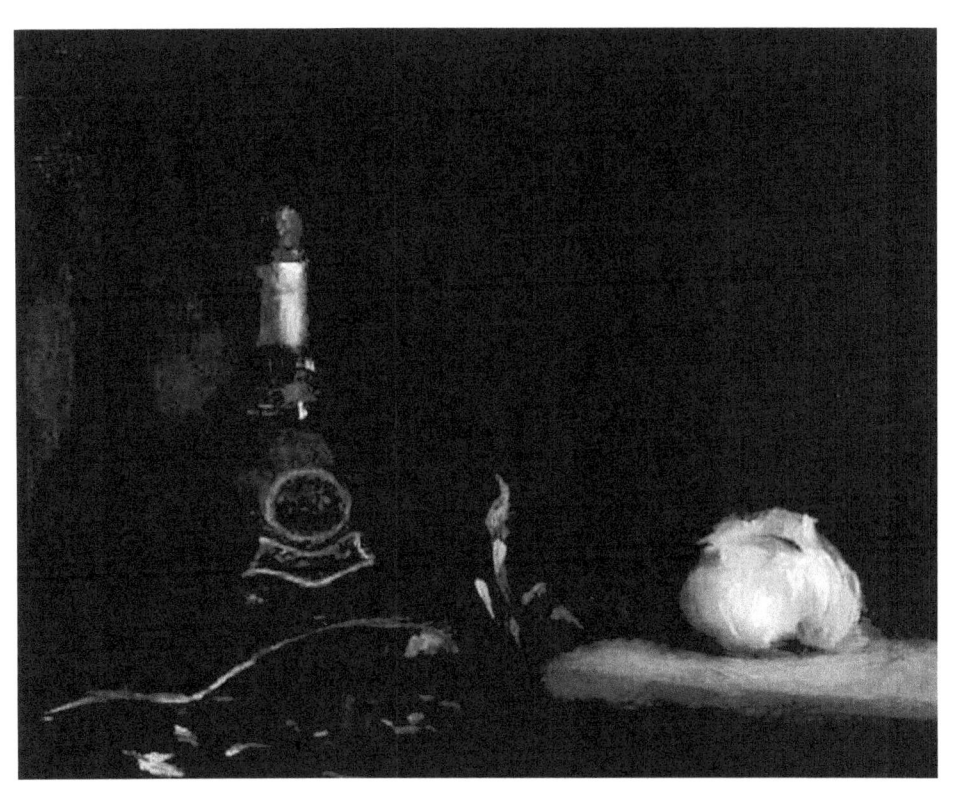

Plate VIII. *Old Apothecary*, 8x10"

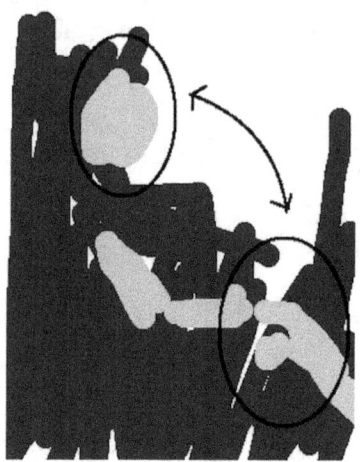

Fig 15. *Detail*. Equivalent to a camera focusing. A concentrated section of detail or smooth rendering tells the viewer what is in focus and what is important. Having, for example, certain elements of your foreground more worked and defined will lead the viewer's attention past elements of loose or abstract brushwork that implies background.

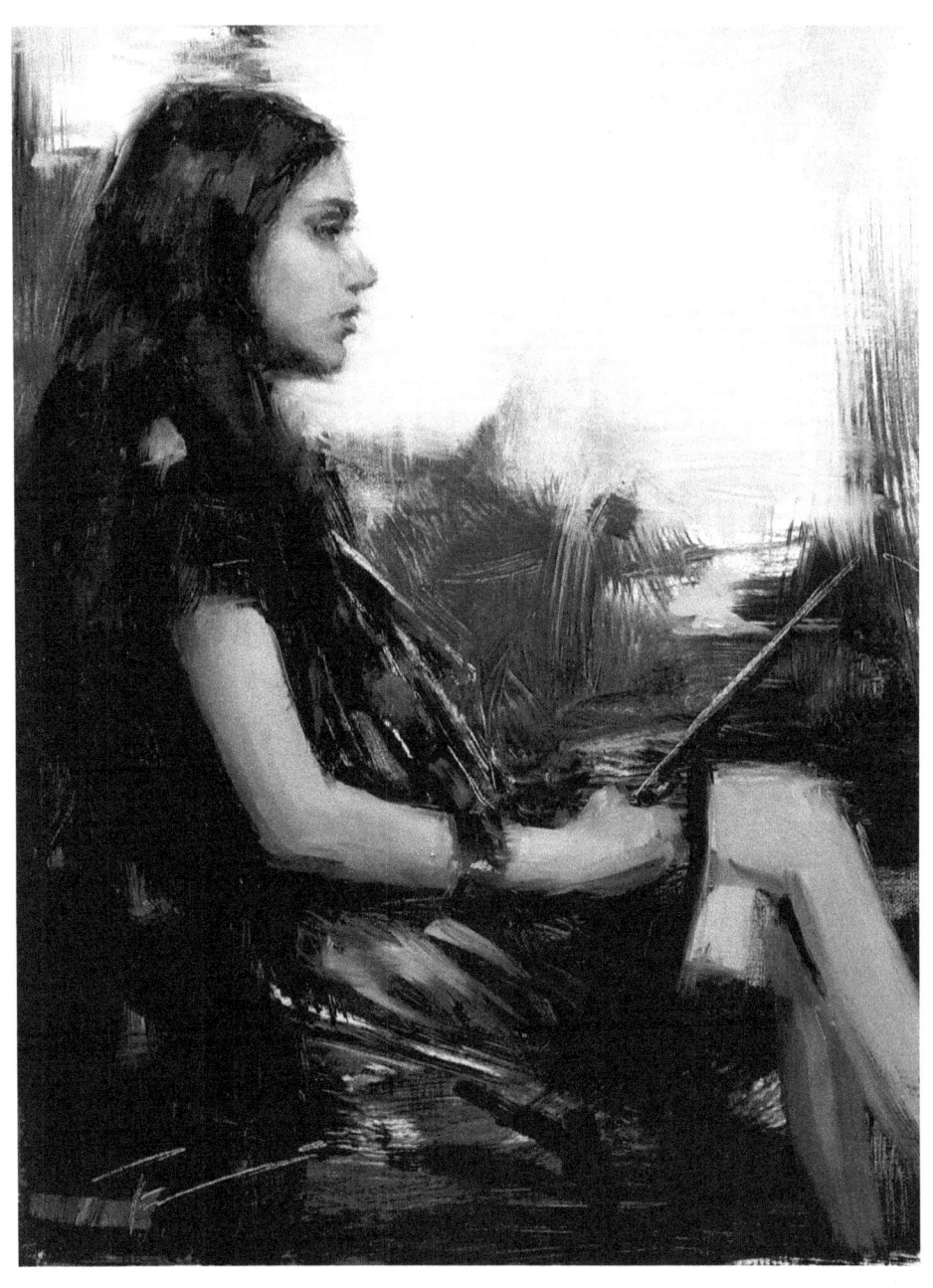

Plate IX. *Concerto in the Park*, 10x8"

Fig 16. *Value*. **Lights and darks pop out right away.** In fact, good values are possibly the best tool for design, as they can be observed from across the room and spotted right away, drawing the viewer toward the painting. A few select spots of light against an overall dark background will lead the viewer across the painting, and vice versa.

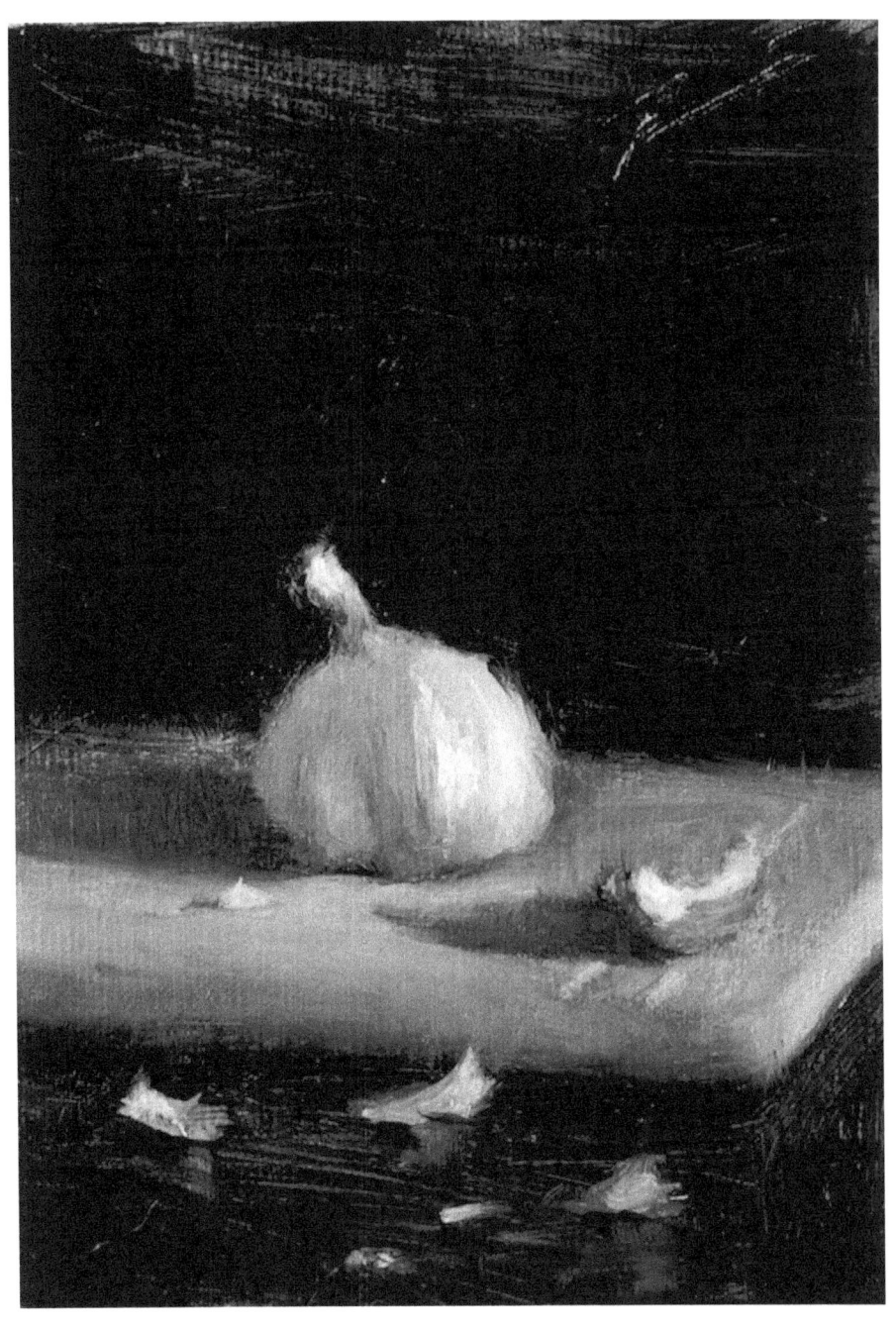

Plate X. *Portrait of a Garlic, 7x5"*

Fig 17. *Paint Application*. Similar to detail, paint application is much more difficult to notice in photographs than in person. Thicker impasto or more layered paint throughout the composition will stand out and lead the viewer over thinner washes.

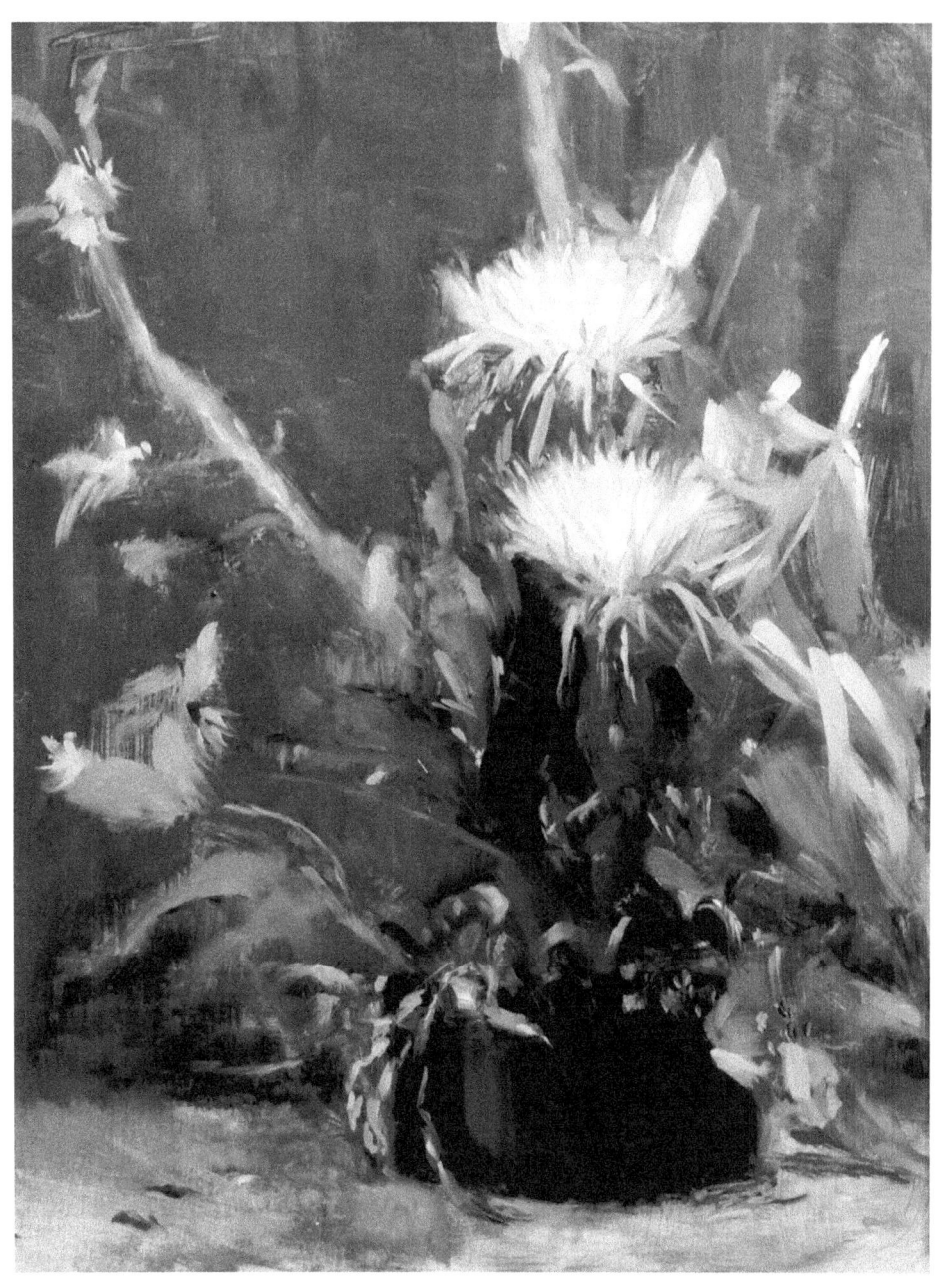

Plate XI. *Mother's Day Bouquet*, 14x11". Private Collection

Color. The same idea as value, but employing brighter or more saturated colors against a more neutral backdrop (or in spaces between interest). On the cover painting, *Minita's Rest*, note how the color, foiled against the neutral backdrop and neutral flesh tones, guides the viewer's eye throughout the painting. The small accent of yellows at the top right on the headdress and the bottom left of the painting also act to push movement throughout. This type of color movement can be eye catching from across the room, but is more difficult to convey in reproductions, depending on the quality.

As you may have noticed, several of these paintings cross over to illustrate several of the ideas of movement. This will help to reinforce movement within a piece. For example, keeping darks thin allows for thicker paint in areas (most likely detail areas), allowing two concepts to push the idea of movement as opposed to one. There are many more methods of creating movement, so be sure to observe nature and master paintings to dissect the ways movement is conveyed. The more methods you have, the more diverse and fresh your paintings will be.

Problem Solving II
THE IMPORTANCE OF DRAWING

 While color is what makes a painting "a painting", drawing is the foundation of that painting, and it plays the largest role in affecting its look of realism. This is what allows paintings reproduced in black and white to still look realistic. Aside from abstract works, a poor drawing will cause a painting to look "wrong." It is necessary to understand the fundamentals of drawing, as well as how they relate to painting itself. The fundamentals themselves are not difficult, but the concepts must be grasped before practice can be usefully applied to create stronger drawings.

 Shape. Exactly as it sounds, shape is the shape an object appears with its relation to light. This is not to say it is an outline. In fact, the shape of something may not resemble at all what you're drawing when you first begin to render it– it may look like an abstract puzzle piece. Let's take a look at some examples:

Fig 18. This is the foundation of a drawing, simplified to its most basic shapes. Though detail is not relevant, accuracy is imperative. Shapes should look abstract, and not necessarily recognizable as the object you're attempting to render. The danger is to get caught up too early in detail or outlines– which are not fundamental to correctness.

Plate XII. The final drawing: a figure. It is easy to see how the original shapes relate to the overall figure to make it look correct, and recognizable as a figure. Make special note how I did not draw any outline or anatomy of a figure; rather, I drew how the *light relates to the anatomy*. This is the importance of shape.

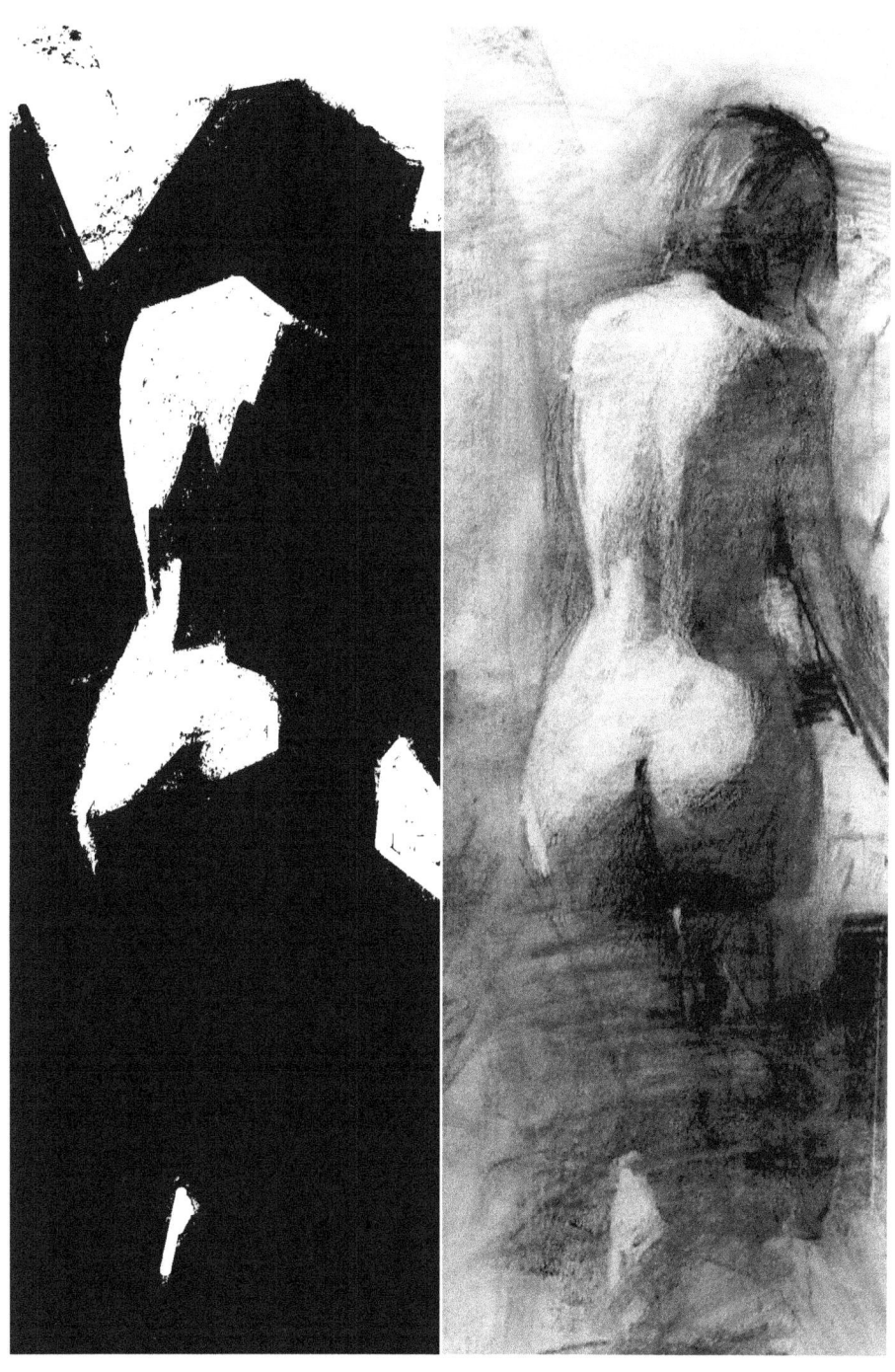

Fig 18

Plate XII. *Figure Sketch (detail)*, 17x14"
Charcoal

Fig 19. Again, this is the foundation of the drawing. All shapes are easily comparable to each other. This obviousness makes corrections and subtle adjustments easier than if it were an outline. An added benefit of this method is seeing how the composition works with a value design, ensuring it is balanced and has movement.

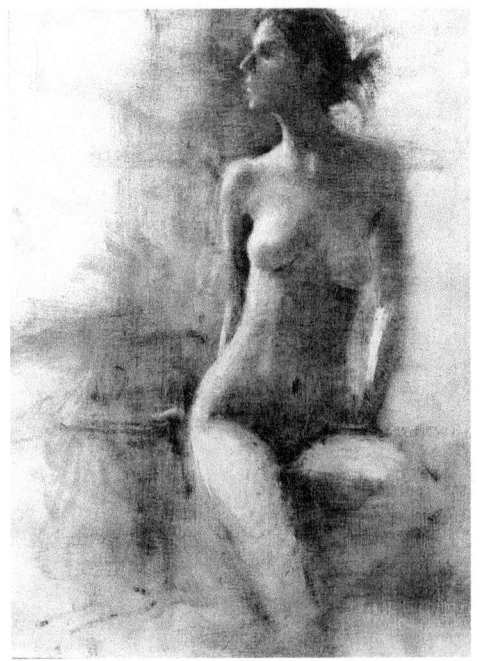

Plate XIII. *Catching the Light*, 12x9"

Plate XIII. The final drawing: another figure. Again, the light falling on the subject is what has been rendered, not the anatomy. Smaller details are reserved for the end of the drawing. Too many shapes in the beginning would cause the drawing to become cluttered, and make it more difficult to relate the larger more important shapes to each other.

When attempting to render something, squint down until everything becomes fuzzy shapes without detail. Attempt to simplify everything into 3 to 5 larger shapes (either black or white). Make sure you place that first basic shape down correctly and you're off to a great start. Later on, you'll compare all other shapes to this first shape to make sure everything has the correct relationship. If your shapes are wrong or in the wrong spot, it should be apparent that they are incorrect. Shape is the most measurable and objective aspect to painting. Everyone should always be able to measure a shape and get the same measurement, though it takes practice.

Value. Value is how light or dark something is. When something is in the light, it has a high value. When it is in shadow, it has a low or dark value. Getting the correct value gives your drawing a 3-dimensional look. Also, if your values are good and correct, your drawing will look better when photographed. A drawing can be successfully executed with a simple 5-value scale, but many artists choose to take advantage of a 10-value scale for more subtle rendering. Although value is measurable via light meters and comparable with scales, each human eye will see value slightly differently, so this aspect is slightly more open to interpretation. Let's take a look at how value affects the realism of a drawing:

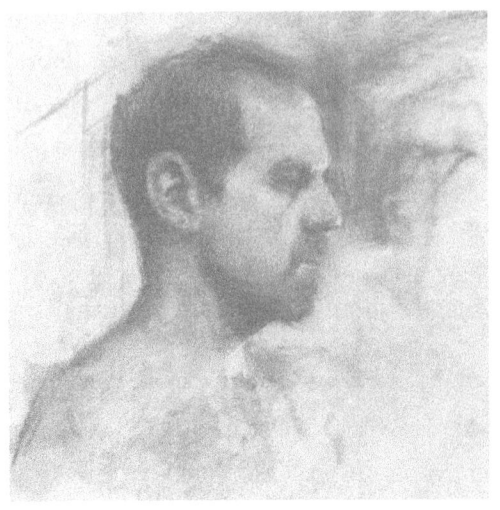 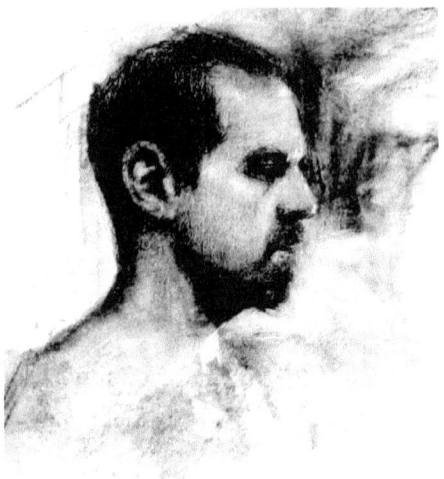

Fig 20 Fig 21

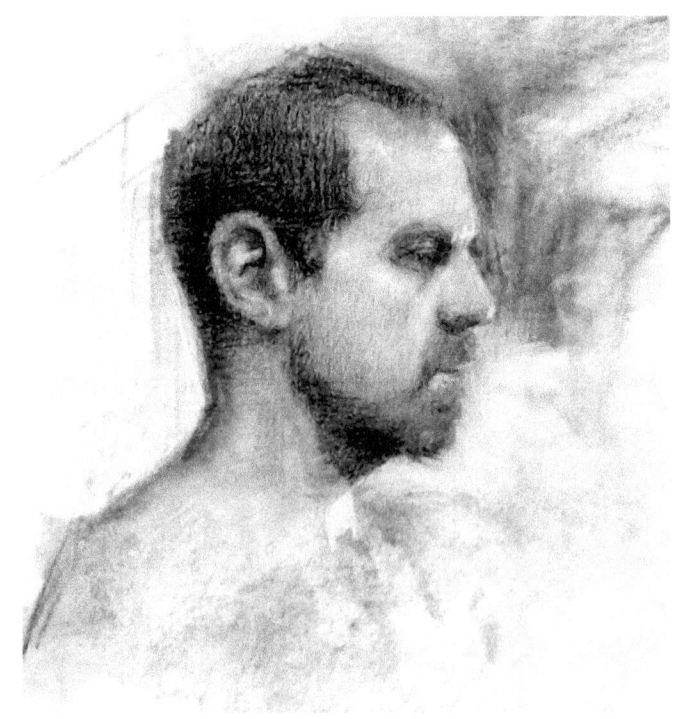

Plate XIV. *Portrait of Dan (detail)*, 17x14". Charcoal

Fig 20. The tendency of many beginners is to work a drawing or painting so much that the values (or value of the colors) migrate toward mid-gray values. It may be difficult to notice in your painting until you become skilled at recognizing what value colors are, but care must be given or you will lose the ability to render most lighting conditions.

Fig 21. Another trap may be to over-emphasize the values, pushing darks too dark and lights too bright. This can happen when the darkest darks and lightest lights are recognized, then pushed all the way to black and white as opposed to their appropriate value. This produces striking work and can be believable in an intensely lit situation, but will not be believable in most other lighting conditions.

Plate XIV. Appropriate value scale within a drawing or painting will add to the sense of realism, allowing the viewer to not only perceive the subject with ease, but to also be able to deduce the type of lighting situation. While the darkest darks are recognized, they are often not pushed to black. All lighting conditions have their limitations.

Edge. Edges are the most open to interpretation. An edge is created when one shape borders another shape. They can range from an unrecognizable soft blended transition of one shape to another, to a razor sharp line. Because of how the human eye focuses, we see reality in a mixture of edges, and tend to look from sharp edges (what the view is focusing on), to the blurred (what would normally be the peripheral vision). This aspect of drawing can create a work very specific to the artist's view of a subject. What one chooses to emphasize will show most with the quality of edges, as well as how that artist is able to perceive a subject simply due to unique biological capacity. Edges are also key in rendering certain effects, such as rounded objects, hair, and light. Pay special attention to edges; if they are all soft, the drawing will lack focus, and if they are all hard, the drawing will look flat and dull.

Plate XV. *Misrek*, 8x10". Private Collection

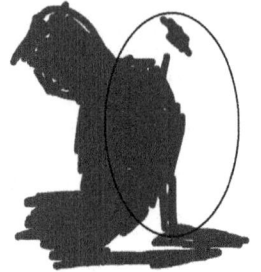

Fig 22. The collection of sharp edges in the center of the painting brings this portion of the painting in focus, allowing the viewer to see the headdress and shoulders in the peripheral.

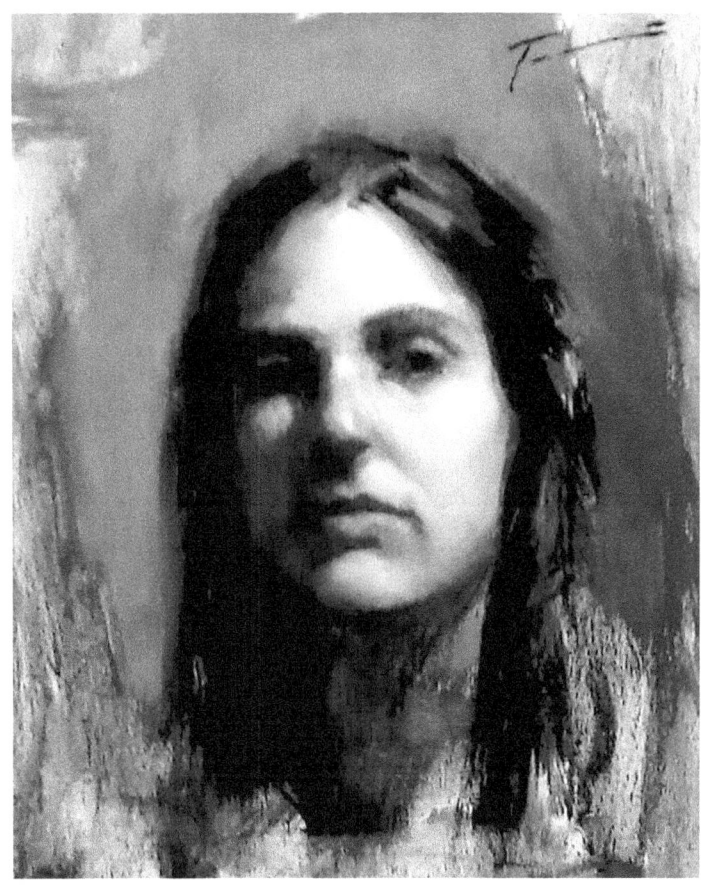

Plate XVI, *Brittany*, 10x8". Private Collection.

Fig 23. Again, the collection of sharp edges at the center (circled in black), brings the face into focus. Meanwhile, the softening of the edges of the hair where it meets the shadow side of the face and the background (circled in white) gives it a wispy effect.

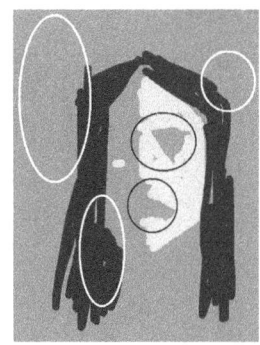

In general, there are 3 occasions in which sharp edges can be easily observed and 3 occasions in which soft edges can be easily observed.

Sharp Edges: 1. Cast shadows. The closer to the source casting the shadow, the sharper the edge

2. Opposite value shapes. The more extreme the values between two shapes, the sharper the edges will be. (Compare the value of the eye triangle shape to the surrounding skin, to the hair and the background value *fig 23*)

3. The focal point. Shapes occurring closer to the area of focus will be sharper in relation to the shapes outside the area of focus.

Soft Edges: 1. Form shadows. A form curving away from a light source will produce a softer edge, or transition. The more gentle the turn, the softer the edge.

2. Similar value shapes. The closer in value two shapes are, the softer the edge will appear.

3. The Focal point. Edges outside the focal point will appear softer in relation.

These are not the only occurrences of edges. Be observant of your subject and *paint the edges you see-* these are only *guides* to help you learn to see them.

TIPS***

- If you've lost the look of the form turning, you may need to soften some edges in your painting.
- Too many sharp edges *make a painting appear flat or graphic.*
- Edges outside of your focal point should appear softer.

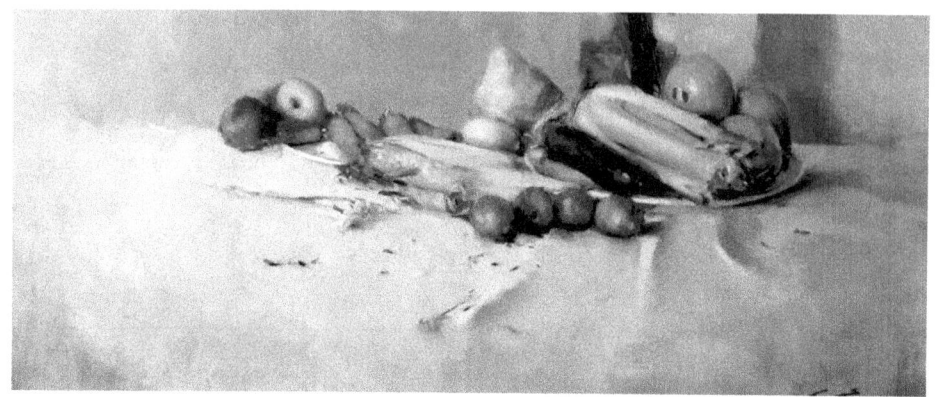

Plate XVII. *Still Life From the Farmers Market*, 10x30"

How Drawing Works In Painting. Drawing is the foundation of painting, simply put. In painting you will deal with the three issues of drawing: shape, value and edge, as well as the introduction of color. But before you get excited and start painting all the colors you see, you must make sure you have the correct shape, that the color you have selected is the correct value, and that each shape you put down has the correct edge. It is not necessary to draw out your subject first (although for those unconfident in their drawing skill it may be more comfortable to do so), but take special care to ensure the drawing aspect is correct, or no amount of color will make your painting look like your subject.

"I'm not sure what's wrong…. Maybe you need more orange?"

CHECK OUT THESE ADDITIONAL RESOURCES!
- "Alla Prima" by Richard Schmid
- "Bargue's Drawing Course" by Charles Bargue
- "Henry Yan's Figure Drawing" by Henry Yan
- "Classical Drawing Atelier" by Juliette Aristides

Problem Solving III
FIXING THE DRAWING

Regardless the approach one takes to execute a painting or drawing, certain techniques can keep it correct, or help to fix it when it starts to stray. Fixing the drawing is the first and most important step towards a successful realist painting.

Measure. You can never do this enough. It's best to follow the carpenter's motto– measure twice, cut once. Measure using any means necessary– any flat edge will do. The most common tool is the handle of the brush or a thin wooden dowel. Completely extend it from your arm, holding it on a parallel plane to your body. Measure shapes and distances using your thumb and the edge of the brush *(fig 24)*. Make several measurement marks, then "connect the dots" *(fig 25)*.

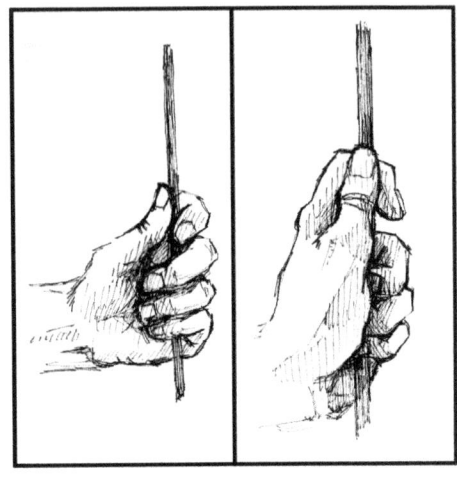

Fig 24. *Use the top of the measuring device and the tip of your thumb to measure.*

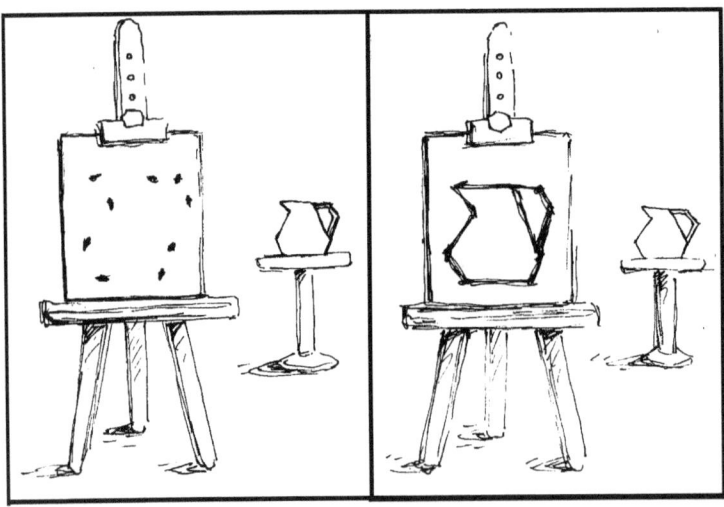

Fig 25. *Measure and plot key points of the subject.*

Follow this with angle comparisons. Tilt your brush left and right. Compare the angles of the diagonal lines between various points on your drawing to imaginary diagonal lines between the same points on your subject *(fig 26)*. Work your way around to verify all the corners and all the points. If all points are in the correct location, all the diagonals made by connecting points on your drawing will create the same diagonals by connecting points on your subject.

The Plumb Line. Make a plumb line to ensure all the shapes along a vertical axis are aligned. Allow a brush, dowel, or weight attached to a string to fall loosely until it hangs vertical, then compare your subject to your painting. Be certain the shapes line up for an accurate drawing. The same method can be used to check shapes on a horizontal axis by holding your measuring tool sideways *(fig 27)*.

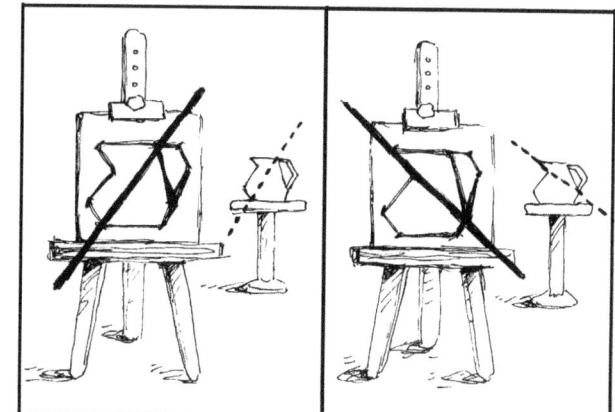

Fig 26. *Checking angles with angular comparisons.*

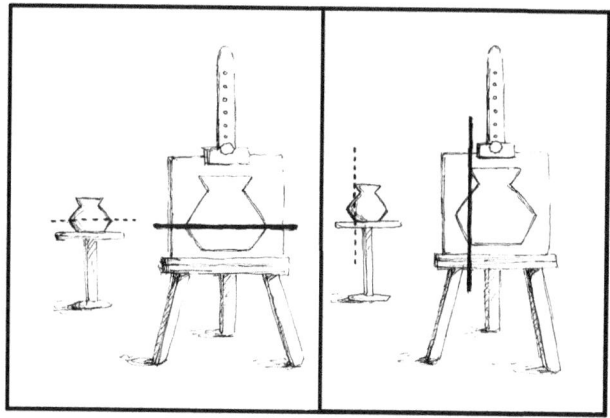

Fig 27. *Horizontal and vertical plumb lines*

Sight Size. This is a method of measurement dating back to the Academic schools of the 1800's. It allows for nonobjective comparative measurement, and will allow yourself or a friend to easily spot anything wrong. By stepping back from the painting to a distance where both the subject and the canvas can be seen side by side, at the same size, a quick comparison can easily point out mistakes (*fig 28*). Do this frequently, at least every other brush stroke, and you can fix mistakes right away.

1. Step back from your subject and canvas until you can see them both side by side.
2. Trace a horizontal line from the subject over to your canvas (as it appears from the selected distance).
3. Make the mark, and step back to verify accuracy.
4. Trace the next horizontal line from your subject over to your canvas (as it appears from the selected distance).
5. Make the mark, and step back to verify accuracy.
6. Repeat steps until image is complete. **Keep stepping back!** To fully utilize sight size, you must continually step back, as the smallest mistake in angles, shapes, or values can go unnoticed if not viewed from the same distance point.

TIP***

If you are dissatisfied with the size of the subject on your canvas and wish it to appear larger, make your point of measurement further away *or* bring you canvas closer to the subject. If you wish it to appear smaller, pull your canvas away from the model *or* make your point of measurement closer to your canvas.

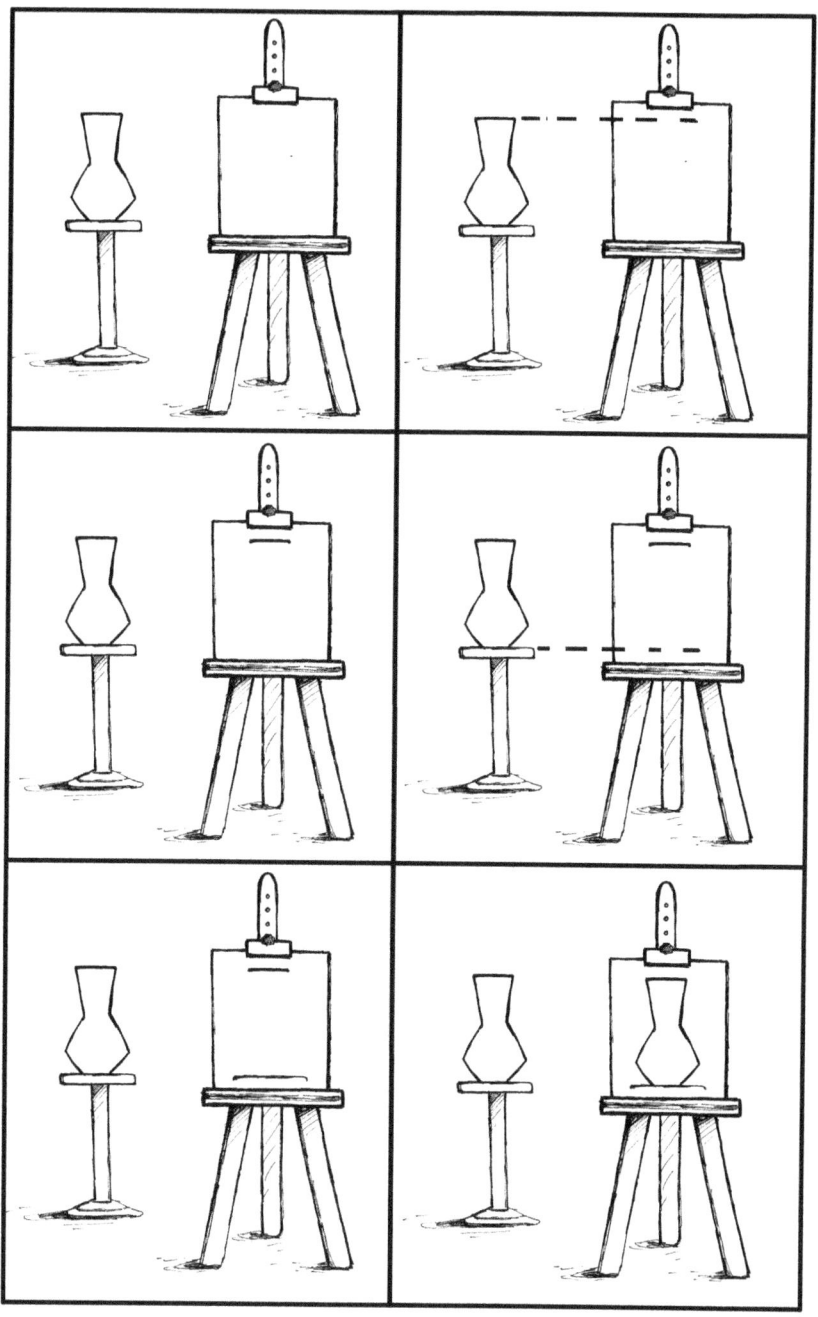

Fig 28. *Sight Size Method*

Take A Photo. A photo of your painting while you're working is probably more useful than a photo of your subject used as reference. Photographing your painting has the same effect as stepping back from your work. You will be able to spot drawing mistakes immediately. The camera has a less biased (albeit skewed) interpretation of your drawing, and will point out incorrect shapes, value errors, and overuse of certain edges.

Problem Solving IV
COLOR

Color adds a whole new complex dimension to the process, one that can be intimidating. Not only is there a challenge in sorting everything out that's in front of you and *seeing* the correct color, one must attempt to reproduce a mixture of that color in the same temperature and value. Lack of confidence can lead to blindly mixing in an attempt to land at the right color. Even putting down initial approximations can lead to incorrect mixing later on when comparing.

"The Golden Rule." The terms "warm" and "cool" are thrown around a lot in the art world, and refer to the temperature of a color. Warmer colors tend to have more yellows, oranges, and reds in them, actually appearing warmer. Conversely cool colors will have more blues, greens, and purples, and seem more calm or cold. When a warm color and cool color are mixed, they might appear "muddy" and have a muted temperature. When looking at your subject, attempt not only to determine the correct color, but the correct temperature. This will make your painting more accurate, more vibrant, and stand out from a distance. Sometimes when looking at a subject, especially in a low light, it is difficult to determine the correct temperature.

Now we come to our golden rule of color. Assuming no other affecting conditions (such as reflected light or multiple light sources), COOL LIGHT WILL PRODUCE *RELATIVELY* WARM SHADOWS and WARM LIGHT WILL PRODUCE *RELATIVELY* COOL SHADOWS. Keep your lights and shadows clean and maintain the correct temperature relationship. Having correct color temperature is more important for the appearance of realistic colors than mixing the exact color you see. Remember, the viewer will not compare your work to your reference, but they will gauge it based off what they typically encounter in life.

Color Schemes. Knowing a color scheme won't really help when trying to paint what you see. There is no greater scheme than direct observation. If you paint the entire composition to reflect the correct lighting condition throughout, then your painting will be correct. Color schemes, such as the use of complementary colors, are little more than personal preference of the viewer or artist. There is no "correct" combination of colors. Unity will come when correct color mixing captures the same uniform lighting conditions

over a scene. When working from life, any desire for certain colors to appear together or interact with each other should be handled during the set up of a painting, not during its execution.

Simple Palette. To gain greater knowledge and skill with your colors, it is helpful to work in a limited palette, or less colors. For example, a full range of values and colors can be created for a figure painting using ivory black, venetian red, yellow ochre, and titanium (or lead) white.

Becoming skilled with any 4 or 5 colors (generally comprised of at least a blue, red, yellow, and white) will produce a surprisingly chromatically rich painting. This is due largely to the principles covered in the "what is oil paint" section. Even if you are uncertain of how to mix color, you only have the potential to add, at most, 4 different pigments to a mixture. This allows more portions of the light spectrum to be reflected back to the viewer creating the appearance of more vibrancy. Attempting to mix the same color with 5 or 10 pigments can easily cause a mixture to get dull and greyed out. While this may be a desired effect, is important to master the potential of a few colors before expanding. An even smaller limited palette of Burnt Sienna, Ultramarine Blue, and White can create a solid range of believable flesh tones, allowing the artist to be concerned more with color temperatures while slowly introducing pigments.

Begin with a few colors, and as you master them add more until you have command over your palette.

Color Charts. The most efficient and direct way of learning color mixing and achieving the color you see is to create and use color charts. Depending on the desired range, one can mix countless colors for reference.

For example, given 2 colors, one can make a row across the top of the chart mixing the two, with a ten square transition from one color to the other. Add white (going down) to each of these gradations (with a ten value scale for each) you now have 100 distinctly different colors, from light to dark, telling you exactly what percentage of color to mix and how much white to add. Mixing each color of a 10-color palette in this way will yield close to 10,000 colors, with directions on how to mix them.

While this may be impressive, it is a bit excessive, especially when the goal of painting is simplification. A more efficient (and transportable) method is to leave out the transition from one color to the next, and reduce each color mixture to a 5-value scale. Mix one color

(predominating) with each other color (subordinate) of your palette. Tint each mixture with 5 values, and you will have 50 colors per chart, with 10 charts. 500 colors is a great start, and a bit easier to transport and handle. The illustration on the following page (*fig 29*) indicates how one would set up a chart for a Blue, indicating which colors one would mix with blue, and how to add white to get 5 values.

When using the chart, hold it directly in front of you (the same plane as the canvas), and compare it to the subject. For whatever spot on the subject you would like to mix, locate it on the chart, and viola! The location on the chart will tell you how to mix it. Now you've eliminated the struggle to see the color (by comparing) and mixing the color (by recognizing the location on the chart).

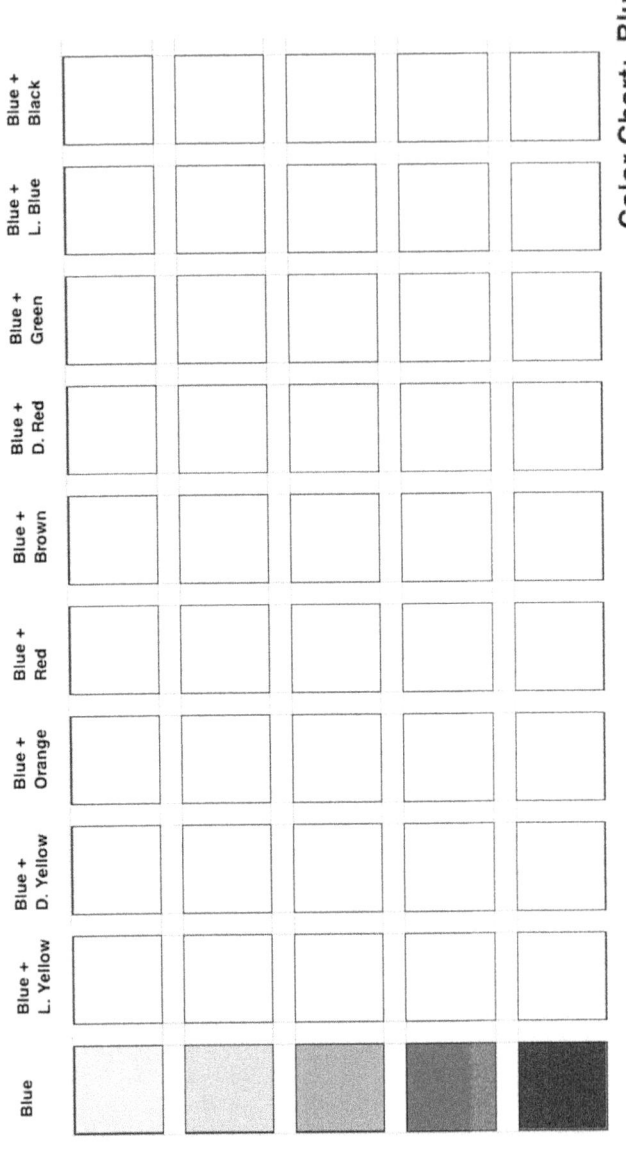

Fig 29. *Color Chart for Blue*

Problem Solving V
GETTING THE COLOR

After getting past the issues of composition and drawing, color can present a challenge. There are a few ideas to consider when dealing with color.

Color and Value Together. When working alla prima or wet into wet, the value is handled at the same time as color. That is to say, the issue is best resolved at the same time. A common mistake is to add black to make a color darker or white to make it lighter. In reality, black will flatten or muddy a color, and adding white will make the color chalky. Why? Because black and white *are* colors, they are just at the opposite ends of the value scale. For example, ivory black is in fact a very dark blue, and mars black is a very dark red– they will alter your colors accordingly. White, on the other hand, is the lightest, coolest color available. If you're not careful, adding white or black will begin to alter the color temperatures in your painting. So what should you do?

Look at your subject! Isolate a small area and really *look* at it. Don't just say it's a darker version of the light area and mix in black. Shadow areas are *completely* different colors than areas in light. Isolate a spot, and mix that color. Don't even *think* about what color was mixed for the light areas. If you catch yourself trying to utilize the puddle you've mixed for a light area and put it in the dark or vise versa, you're just being lazy. Make a new color. Soon you will realize that while you are painting you don't even have to worry about value. All you really need to worry about is mixing the appropriate color!

Isolate the Color. With so many colors in and surrounding your subject, it can be very difficult to have an unbiased judgment of what color you are actually seeing. It is helpful to hold up a white sheet of paper, paper towel- anything, at arms length and next to the note of color you are painting. Now you have a basis for comparison. Mix your color and place

"So these help you see more color?"

it on the canvas, holding your white sheet next to it. When the two match: success. Often artists will use a color isolator- a card painted white, black, or gray, with a hole cut out. This allows the artist to see the color surrounded by a consistent field of value from which to compare. See page 135 for a color isolator.

Mixing the Right Color. Now that you know how to *see* the color, you must be able to mix it. No matter what your level of skill, it is beneficial to produce color charts. Think of them as your reference guide. Once you know what color you need to mix, the chart tells you how to do it. You can save yourself years of practicing handling color with the amount of knowledge you will gain from the charts. Keep them at your side, years if necessary, until you are really familiar with how to mix all the notes.

TIPS***
- Don't add white or black to your colors to adjust the value.
- *See* the correct color first (holding up a white sheet helps)
- Mix the right color (for better accuracy, use a chart)
- Remember the golden rule! (cool light= warm shadows and warm light = cool shadows)

Problem Solving VI
PHOTOGRAPHS

With so much controversy on the use of photos, it is worth mentioning the pros, cons, and most effective ways to use them. Almost all artists use them, but almost no artist relies solely on them. Take from them only what you need to help with your problem solving.

How Photos Are Different. A photo is a very specific interpretation of the device used to capture it, or more specifically, what type of camera. 100 different cameras photographing the same exact subject will in fact produce 100 distinctly different images. The color, value, and edges will vary. The most effective use of the photograph, therefore, is for the shapes of objects. It is much easier (especially when using a grid system) to translate the shape of objects from photo to canvas. There are several reasons for this:

1. The photo never moves like a model might.
2. The photo never takes a break, therefore remains in the same position.
3. A photo can be printed on the exact same scale as the canvas.

Why Photos Are Different. Cameras produce very unique photos (that are different from what we see) for various reasons. Among cameras, the quality and design of a lens can affect clarity and color rendition. The body of the camera itself can play part in the over-saturation of the images, as well as the volume of detail the camera is able to produce.

Compared to humans, cameras are different in several key features. The most obvious is the number of lenses versus eyes. Having two eyes immediately adds depth and a more precise field of vision (though we are usually unaware of this). This is important for creating much of the edgework that makes a painting so realistic. Humans also have the ability to see some lighting effects a camera is unable to easily capture. More knowledge of how to operate a camera can help to compensate and produce a better reference of edges and appropriate amounts and saturation of color.

The human eye allows us to see vastly more amounts of knowledge, enabling us to be as selective as desired when producing a piece. Cameras, some with the ability to capture large amounts of detail, will be indiscriminate in their selection of important details. Always remember: A CAMERA ONLY CAN RECORD A FLAT IMAGE, LIMITED TO ITS DESIGN FLAWS.

Using the Photos. When using a photo it is important to take note of the

common errors of photos:

The Color. Without a great deal of editing in a program like Photoshop, the color will never look exactly as you perceive it. Even if you do get the image on your monitor to look correct, it will look different on all other monitors and in print. Therefore, if you are using photographs, *always do a color sketch*. This will ensure you are using appropriate saturations and temperatures. Another method of creating believable colors is to limit the saturation of the color scheme or to work within a limited palette. This will reduce the risk of mixing a color that cannot exist within the lighting conditions you are attempting to paint.

Incorrect Value and Temperatures. Most cameras will tend to darken the shadows inappropriately, and in doing so also may make these shadows the incorrect temperature. Therefore, *adjust to have the correct value and temperature in the shadows*.

If you are uncertain, reduce the amount of darkest darks. Our eyes aren't accustomed to seeing an overabundance of darks. If an excess of darks were to occur, our pupils would dilate to allow us to perceive more light, readjusting the value scale of a scene. This is not to say the darks will be light, but the amount of the darkest darks would be reduced.

Also, be observant of the temperature of light source used in the reference photo. If a cool light source is used, the darks should be comparatively warmer, even if a photograph makes them dark and cool. This is one reason why photos (at least those taken by non-professionals) might look flat, while paintings can glow.

Skewed Perspective. When photographing a subject too closely, the camera might produce a fisheye effect, curving some lines that should be straight, or exaggerating the foreshortening. This is the result of having one lens instead of two eyes. To compensate for this when taking a photo, STEP AS FAR BACK FROM YOUR SUBJECT AS POSSIBLE, THEN ZOOM IN. This may not completely eliminate these issues, but it will help. If photographing on a camera

"Most people wait till the model's done posing to start working from a camera."

without zoom, adjust the setting to increase the size of the photograph file, then step back. You will have to zoom in on the photo after it's been taken.

TIPS***

- The most effective use of a well photographed reference photograph is to obtain correct shape in your drawing.
- Use photos to check your painting. It will have the same effect as stepping back from your canvas, where you will notice shape issues right away.

Problem Solving VII
Effective Studying

A key element of ones growth as an artist comes in recognizing admirable works and artists, and learning what skills or techniques are employed to make them admirable. By recognizing and obtaining these skills, ones "arsenal of artistic weaponry" will grow, as will the ability to successfully and more efficiently execute work. What follows is a brief guide on HOW to study, and gain more from it.

Keeping References. The first step lies in exposure. By gaining more knowledge of what is available, one has more options to pursue. Visiting museums and keeping books by historically significant artists, such as Sargent, Michelangelo, Rembrandt, etc. is a good start. Also, in the last 5 years magazines have grown drastically in quality, and are fantastic for a good breadth of exposure featuring articles on historic and contemporary artists, as well as articles that explore demos, color palettes, and techniques. Buy these magazines and scour them for work you find admirable, and cut out the pages you like. Place them in sheet protectors and combine them in a binder.

Soon, you will have a book filled with what you consider the highest quality of work. These magazines gives one the opportunity to collect beautiful images and suggest artists you may like. Take it further and explore the internet through such sites as the Art Renewal Center for large collections of paintings by historical and contemporary masters. You will soon discover that there are more artists than you could possibly imagine, both living and dead. For a jumpstart, the appendix in the back of the book lists dozens of great artists, each having their own techniques, or solutions, to the problems of painting.

Breaking Down the Magic. Now that you have an impressive collection of images and artists, it's time to figure out WHY you like them so much. Forget ideas that the artist is just too amazing- a genius beyond grasp. Forget ideas that they may be endowed with a "better sense of color" or are some sort of prodigy. *Remember* they reached their level with a LOT of practice, and building on a fairly universal (and very understandable) set of rules, slowly, and often one at a time. Everything within their paintings relate to composition, shape, value, edge, color, paint application, and the *choices* they made about each one.

Keeping this in mind, now look at one of the images and start to ask specific,

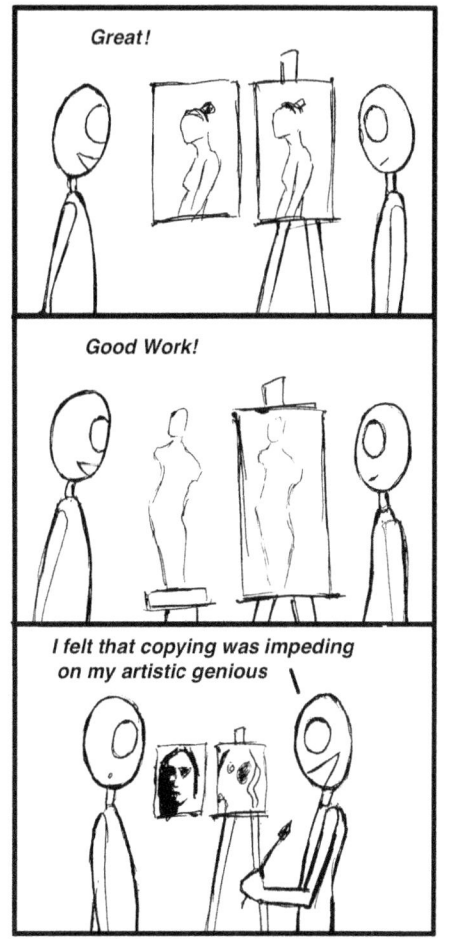

answerable questions. Not as general as "why do I like it", but more empirical questions, or those that have a clear yes or no answer, such as "is the color attractive to me?" "is it the gestural design?" "the values?" "the atmosphere?– is it very soft with loose edges or very tight?" Often a good work of art may have all of these things, so pick one to start.

Pull together many works you like from a single artist and focus on one element, such as edges, and study how each work uses them. The next time you work, think specifically of these edges, and make that the focus of your painting. Keep working on that element again and again until you have become comfortable and confident doing it in the same manner as the artist. Don't worry about copying, worry about learning. Once you master how one artist handles edges, pursue another you like, and work to perfect that. As you learn more ways to render edges, you will find that you like certain methods more than others, either because of the actual act of doing them or the finished look. Soon you will have your own edges. Repeat this with each aspect of a painting or artist you like.

STEP 1. Collect many images of an admired artist
STEP 2. Deduce a specific single thing you like about them
STEP 3. Practice using the same aspect (such as edges) of that artist's work until it becomes second nature.
STEP 4. Repeat, with as many artists and specific aspects as you can

Remember, there is no magic! Don't just admire it, DO it!

TIP***

- Every time we set up in front of an easel, even for practice, we should always have a goal. Aimless practice means hours wasted. It is unfortunate the number of artists I have encountered who have shrugged off unsuccessful paintings as "just practice" because they were unwilling to commit full mental focus to their work. More than any other time, this is when we pay attention. The harder one works while practicing or studying, the easier the execution of more completed pieces will be.

Chapter 3
Assignments

For the serious student I have included five assignments to be completed outside of the classroom. Although they do not require much time to complete, they help to reinforce fundamentals, greatly strengthen compositional skill, and help the artist to begin the problem solving process before any issues arise.

The assignments are actually tools that can (and often are) used by artists to help conceive strong paintings and to work out any areas of concern. They make the actual painting process go by much more quickly, because they provide accurate reference throughout. Artists such as John Singer Sargent, William Bouguereau, and Rembrandt used some or all of these techniques quite often.

Aside from their aid in painting production, they help to sharpen hand-eye coordination, train the eye to see things that might otherwise be difficult to see, and exercise the mind to explore stronger ideas.

Assignment I

Composition

The goal of this assignment is to push oneself to create interesting compositions, as well as help identify potential problems that may arise later on in an arrangement.

Find a handful of objects, between 3 and 10, and arrange them into a composition. Keep in mind ideas of contrast, size of objects, value of objects, and movement created. Use all of these to create a small setup that leads the eye around to all of the objects. Next, make a small sketch, no larger than 2x3", in broad charcoal or thick marker. Approximate the values, but don't attempt to render details— just create general shapes. Avoid outlining, as this will artificially add lines that would not appear in a final painting. Only spend a few minutes at most on this, as it is intended only to be a thumbnail sketch. Remember, *the shape/value of the background is as important to the overall composition as the shapes of the objects themselves.*

Rearrange the same objects on the same surface and repeat the sketching process. Do this until you have completed at least 5 to 10 sketches (*fig 30*). Soon you will start to become more comfortable with creating small dynamic arrangements, notice what looks awkward, and what compositional elements appeal most to you. Again, if you aren't filling in appropriate background shapes and colors, you won't be sketching the true compositional value of the arrangement.

1. Horizon line shifted 2. Vantage point adjusted.

3. Weight/counterweight 4. Central mass 5. One object focus

Fig 30. *Quick sketches of three objects*, **rearranged, creating different compositional strengths.**

The final arrangement selected was number 3 (see **Plate I**)

Assignment II

Color Block-in Sketch

Building on the thumbnails, this assignment is intended to help strengthen compositional skill, with the addition of color. The sketch will serve to help create a quick reference for accurate color, as well as give a more accurate idea of what the finished painting will look like.

Begin with a small canvas, around 5x7". Limit the time of these to 30 minutes: 5 minutes at most for drawing, then 25 minutes of color application. Too much time spent on the color sketch will push you past a strong block-in and into possible unclean, muddy details. Don't be afraid to pile on the paint, and work with one medium sized brush for lights and one for darks. The key here is to be impulsive. Never let your eyes adjust too much on your subject, just occasionally glance up to see a color then go back to mixing. The more you focus, the more your perception of color changes. Avoid making anything pure white or laying in any dark darks– you're focusing on color, not value. You will learn a little about color mixing, but a lot about color SEEING. Use a more absorbent canvas for this, as you want the paint to dry faster, and you won't be making corrections. Do as many as you can (try to shoot for one a day). Make sure you apply a color stroke for all the things you see (if you are doing a still life, remember the background and table are just as important colors as any of the objects). In the end you should have what appears to be color blobs or shapes scattered throughout the small canvas.

Look at your sketch and determine if it has elements of strong composition. Is there eye movement? Is there a sense of balance? Is there an element or shape that pops out? Decide what you might like to change about the small color sketch, then rearrange the same objects. Paint the new setup in the same fashion– in 30 minutes.

You will begin to see how to create strong, accurate color sketches, and when using these to aid with the final painting of a setup, your painting will have cleaner color and more thoughtful design.

Note how the color sketches on the right *(fig 31-32)*, help to work out color, as well as ensure strong composition via value and diagonals. Elements were taken from each sketch to influence the final painting (**plate XVIII**).

Fig 31 Fig 32

Plate XVIII. *Melissa,* 14x11"

Assignment III

Charcoal Head Sketches

This is similar to Assignment I in its goal to produce small thumbnail sketches in either broad charcoal or marker, although the focus is somewhat different. The idea is to break the face down into large connecting shapes. If done appropriately, a likeness of the model should appear within as little as 2-5 minutes of drawing.

Find someone willing to pose– each drawing should range from 2 to 5 minutes. Place them in a location where there is a strong, bright light source to the side or above them. Squint down until all detail is gone, and all you see are the big shadow shapes on the face– 2 values, light and dark.

Render these shadow shapes simply, but accurately. Spend the majority of the 2-5 minutes making certain the shapes are in the appropriate location and are the correct size. Again, do not attempt to draw details, but focus on the correct shape. If you have done it simply and placed everything correctly, a likeness should emerge with as little as 3-5 shapes (*fig 33-35*).

Complete at least five of these small drawings (no larger than 5x7"). If you are having difficulty seeing only lights and darks, move the light source closer to the model until everything becomes VERY bright and VERY dark. If done correctly, they should very much resemble photos from old newspapers.

Fig 33. 5 light shapes (or two complex dark shapes) produce this dramatic portrait.

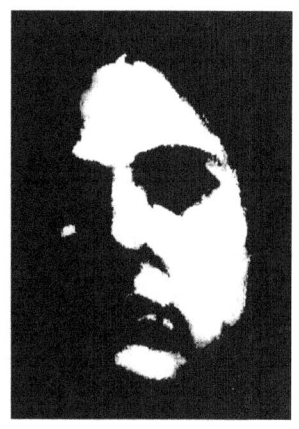

Fig 34. This more complex drawing has 6 light shapes (or one dark shape).

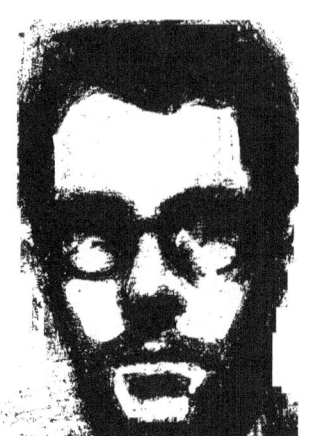

Fig 35. 5 light shapes indicate head tilt, features, and shoulders in this portrait.

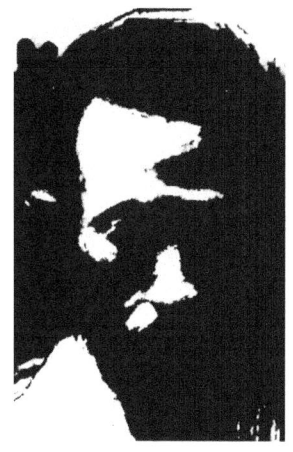

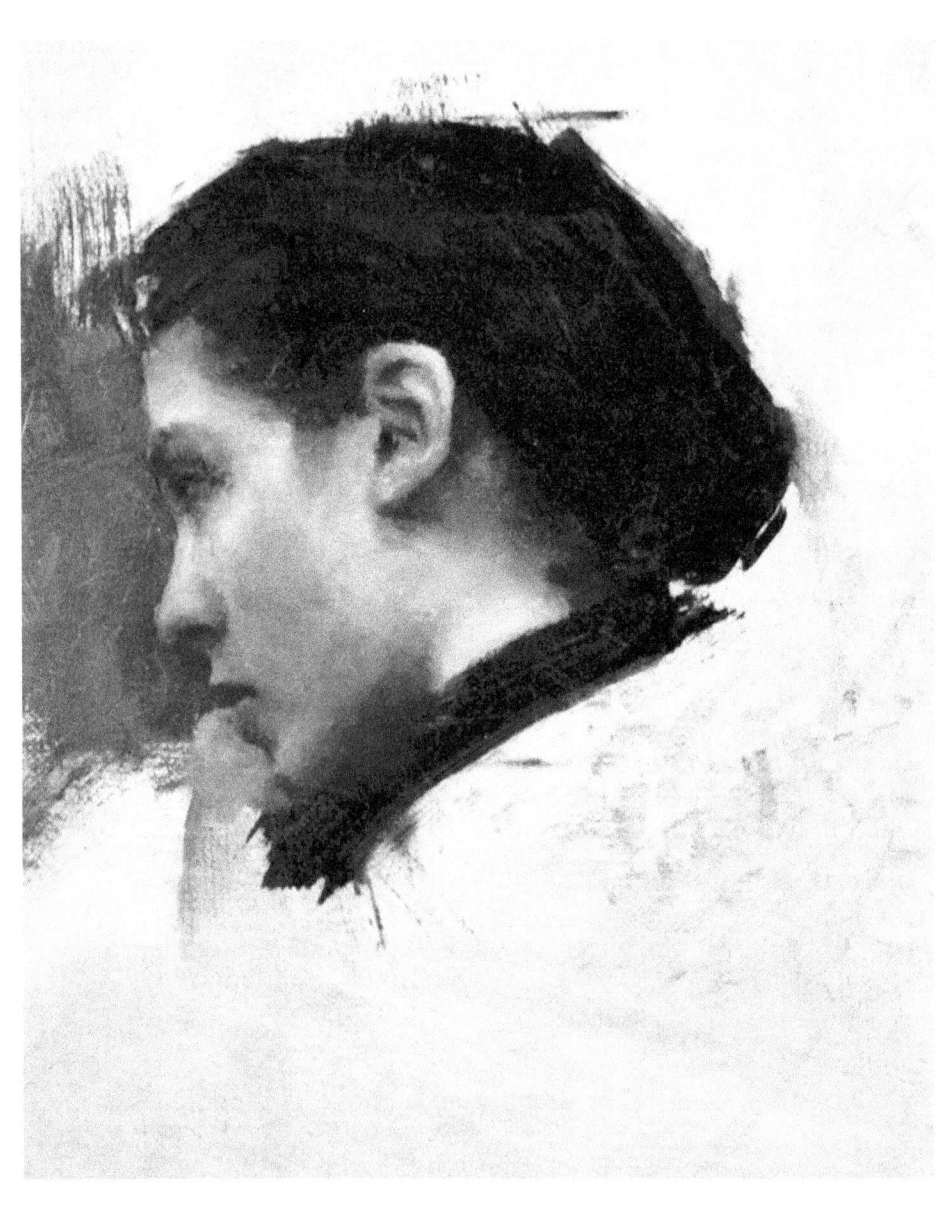

Plate XIX. *Copy After Friant,* 12x9"

Assignment IV

Master Copy

Master copying is good practice in general because it immerses you in techniques of the past, allowing you to discern for yourself working methods, styles, and choices made by artists of the past. It is particularly relevant to problem solving in the manner it is used for this assignment.

At this point, the in-class portrait will be halfway complete. This is a very appropriate time to stop and review the progress made so far. Perhaps there is an issue that you are struggling with and are unable to move past. Maybe the painting doesn't have a sense of unity. Maybe the highlights don't seem to have enough color, or perhaps the darks don't. Now it is time to turn to the masters and see how they handled the same situation.

There is a belief held by some that in an art world of realism, everything's been done already. This is fortunate for the learning artist, as it leaves goals to shoot for and pathways to get there. The assignment now is to seek out an artist who has handled a model in relatively the same pose, with relatively the same lighting. With the plethora of masterworks in existence, this should not be difficult.

Once you have located a painting with similar format by an artist of admiration, print a color copy (at home or any print or photo shop) that is no larger than the size the file will allow before pixilation. Make certain you have cropped the image so that the face fills a large portion of the printout. If you are unable to work from a print, try to use a quality monitor.

Over the next week, working on an 8x10" canvas, paint as close a copy as you can to the printout. Use all the problem solving techniques discussed thus far, and make it as accurate as possible. Take *special* note of the master's use of color, value, edges, and shape. These are the things that you will be taking away to incorporate into your in-class painting to help with any problems you may be having.

Assignment V

Independent Learning

Really start to think about what makes a composition that is appealing to you. Look in magazines, books, or online for paintings you like. Then, using a thick black marker or thick charcoal, make a small thumbnail sketch (no bigger than a few inches), to describe the strong diagonals, lines, or value. It is not important that the sketch looks like the work you are looking at, it's important you capture the basic composition *(fig 36)*. Do hundreds. Doing this will help you immediately start to isolate aspects of still life, landscape, and figurative setups that will make strong compositions.

Fig 36. *Compositional sketches of paintings*

APPENDIX

What follows now are various topics relating to the idea of troubleshooting a painting. These are tips or ideas that were not originally incorporated into the format of the 5-week class, but would often arise as students worked through the assignments. These are not intended as tricks to boost the appeal of one's painting. They are possible solutions to many problems you will face during the long path of painting. Some may seem obvious; others may open whole new avenues to explore. Hopefully, some of them will initiate those moments of enlightenment that push us to the next level. This is by no means a complete list, but a good start on a varied range of topics. Remember, no trickery will trump observation. If you paint what you see– what you honestly see– it will look correct. It's the learning *how* to see that takes a little help and a lifetime of work.

It's a good idea to view each painting as a learning process. Avoid falling into formulas of repeated ideas, arrangements, and subjects simply because you have had success with them in the past. The greater the number of topics and lighting situations you attempt to work in, the more knowledge you will gain, often illuminating solutions to problems with previous paintings. This will cause you to expand upon this problem solving list with discoveries of your own. This is not to say you will never change your style, but there will always be room for improvement. The best living artists are the ones who, to our amazement, keep topping their previous work.

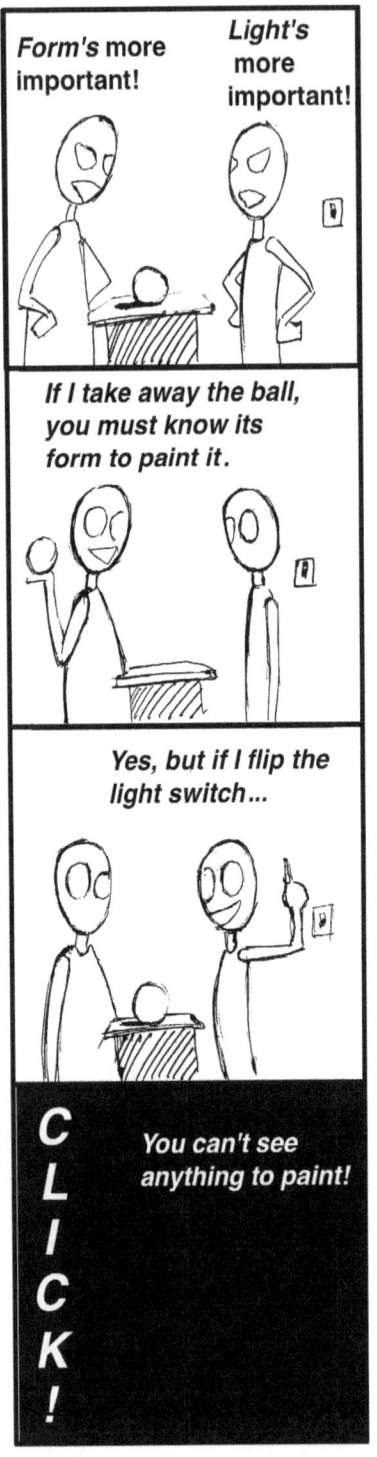

I. Rendering Light vs. Form

Traditional paintings, prior to the mid 19th century, were very focused on the rendering of the individual aspects of their paintings, such as figures, objects, or backgrounds. They were produced most often to tell the story, allegorical or personal. The subjects of these paintings were always obvious, because they were the objects being painted.

As such, lighting conditions were chosen to better illuminate the subject being painted. This is obvious in works such as the Sistine Chapel, where Michelangelo, for example, incorporates a carefully selected amount of light to precisely describe the anatomy of his figures. Artists such as Caravaggio used light to create drama in his figures, but the figures themselves are still obviously the subject. This treatment of drawings and paintings has survived and now exists in some schools that prioritize anatomical knowledge above all else. They follow a rigid dogma: without anatomy, light would have nothing to illuminate.

The mid 19th century spawned the greatest breakthrough of painting in 3 centuries, Impressionism. With Impressionism came the story of light. Objects were present, but only in their capacity to illustrate light, atmosphere, and color. Drawing became unimportant in the eyes of the Impressionists (the anatomy of the objects in their paintings was not the subject) and often was poor, sometimes to the extent of being

distracting. What they lacked in drawing they made up for in light. Paintings became bright, looking as if light was emitting from within.

Monet is a prime example of this. His paintings of haystacks, lilies, and gothic towers glow. They are a triumph of the discoveries made about color temperature, reflected lights, and color harmonies of believable lighting conditions. Even methods of paint application were influenced, with the introduction of broken colors and visual blending of colors (as opposed to colors mixed, applied, and softened). This method of painting, painting the light, still very much exists today. In fact, it is the counter to the anatomical school of thought: Without light, form would not be perceived.

This is not a suggestion to pick one school of thought and be completely devout. In fact, many Academic artists of the late 19th century, previously of the form school of thought, began to incorporate more impressionistic colors into their works to heighten the realism. Alma-Tadema is one such example, whose colors bloomed from passably believable to glowing with light.

Herein lies the problem solving tip:

Know what your subject is. Know what exactly it is you want to convey. Do you want to paint an antique because it is fascinating, or do you want to paint it because the light spills in beautifully from the window and drapes it in a mysterious glow? To show how fascinating it is, you may need several lights illuminating the subject to show ornate detail and textures. However, if you want to capture the lighting effect upon it, you may be forced to sacrifice the shadows or simplify some of the tidbits that made it so interesting.

All too often students are unclear in what it is they are trying to convey, and then they start pushing paint around, or rendering too many things that should not be. Remember, the characteristic that defines any great masterwork, from either school of thought, is clarity of idea. Lets look at some paintings with clear intent:

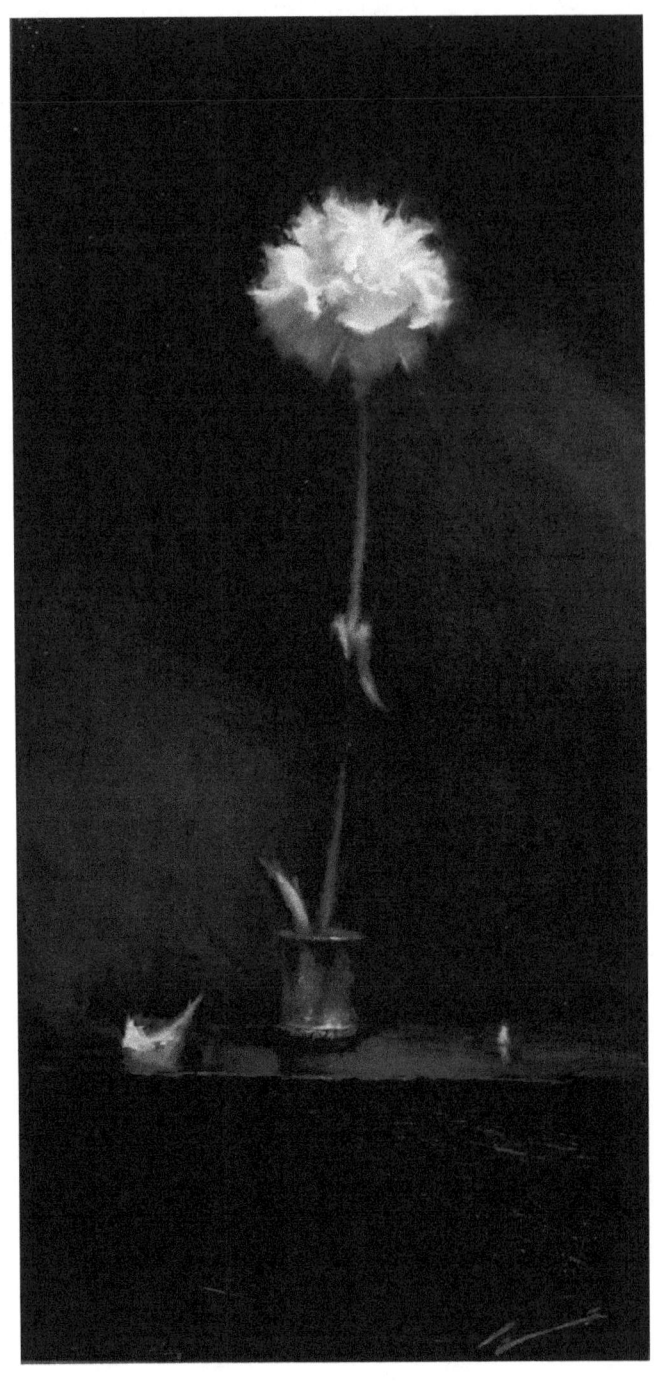

Plate XX. *Carnation Falling*, 20x10". Private Collection

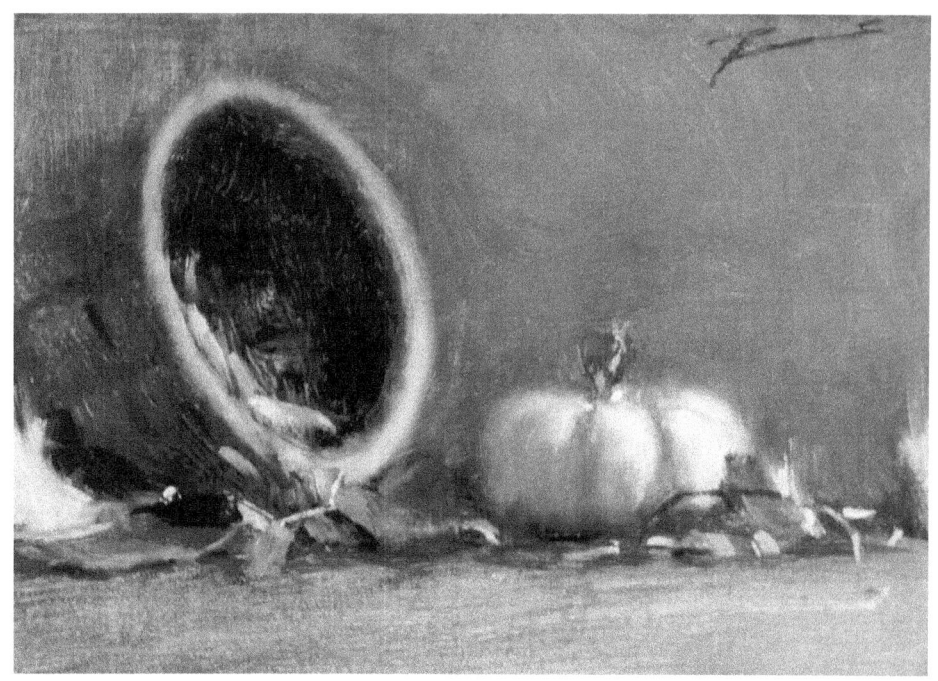

Plate XXI. *Autumn Bouquet*, 5x7". Private Collection

The subject of **plate XX** is the flower in its antique vase, delicately balanced to stand straight. The lighting conditions are crafted around the subject to describe the nuances of the petals, and the textures of the vase. Even without color, the strong design is obvious.

In **plate XXI** the subject has shifted to the color and light. Again, this is not as impactful when reduced to black and white, and it has the potential to lose some of its character when reproduced. Many of the values are simplified and the details are lost to create the soft, wispy edges to indicate the atmosphere and the flood of light spilling around the objects.

II. Color Mixing

Along the same vein of older Academics versus Impressionists comes the issue of color mixing, in which two methods become apparent:

> 1. Mixing saturated colors, applying them to the canvas, and having them (hopefully) optically blend together to make a more neutralized, natural scheme.
> 2. Mixing neutralized colors, applying them to the canvas, and slowly modulating the mixtures to create a unified, natural color scheme.

Ultimately the end product should be relatively similar, at least when seen from a distance or reduced into a photograph. It is much easier for problems to arise in the first method, which is the natural inclination for most students to work, so it is worth mentioning what happens, why, and how to avoid it.

When viewing a subject, we see all colors in their relation to each other, which will in fact alter our perception of individual colors within that subject. Orange, for example, will *appear* more intensely orange and brighter when placed adjacent to its complement, blue. If one were to isolate that orange with a color isolator (as mentioned in the color section), it would be perceived at its actual value and intensity. Unfortunately, despite my best efforts, it is difficult to keep students using an isolator throughout the course of a painting.

Without the isolator and with less experience, the student will begin to mix overly colorful mixtures to match their perception, until they have a rainbow of paint that can't possibly exist in the lighting condition they are attempting to render. Occasionally these intensely bright colors will work to neutralize each other, allowing a passable painting, but that is generally by luck.

This is not to say one should not apply paint in this method. Done correctly, it can be a triumph of simple, beautiful notes. If one were to isolate any portion of the painting it would appear as visual candy. To see examples of this treatment successfully, seek out paintings by contemporary masters Clayton Beck and Daniel Keys. It is imperative to view these pieces in person or at high resolution, in order that the rich color note strokes can be observed. The best approaches I have found to learn this method are twofold: color sketches, and painting landscapes and floral paintings.

Color sketches (mentioned in the homework assignments), allow one to disregard

drawing and become better at seeing how simplified, pure notes of color relate to the harmony as a whole. There is no opportunity for subtle gradations in a 20-minute sketch, so achieving strong color from the beginning is imperative. It may be difficult to achieve at first, but a 20- or 30-minute color sketch a day will be, along with color charts, the greatest education in color one can hope to receive.

Landscape and floral paintings can be similar to color sketches in that drawing is of less importance compared to color and brushwork. The only difference is an extended amount of time. Take advantage of this extra time by thinking more about the correct brush stroke and color note to make, as opposed to making more. 100 correct brush strokes will do more for good color than 500 haphazard ones. Landscapes and flowers are filled with color, so study them. It is important to note that this method of paint application will require a full range of palette colors, in order to reach the intensity perceived.

The second method is somewhat of the reverse, starting with unity and building or modifying color into it. A carefully selected, sometimes neutralized, color is mixed for an area. The color is then thoughtfully modified, the temperature or value altered, as the artist slowly works around the painting. Any given area of this painting, when isolated, may appear as a gray or neutral, but when viewed as a whole will have the same strength of color built in.

This method is a good working habit for those who have trouble with color, pushing it too far away from a believable range. It is similar to working in a limited palette in that it has a unifying effect. By working in this method, it will become glaringly apparent when a color of too great intensity has been mixed, as it will overshadow all previous colors laid down. This does, however, require a very sensitive eye, as the color modulations must be very precise. Jeremy Lipking and Joseph Todorovitch are masters at this careful harmony, with the ability to probe around a range of delicate neutrals.

Ultimately, your style of mixing will become a matter of preference to the look of a painting upon closer inspection. Consider shifting your method if you are having difficulty.

III. The Problem of Light Sources

Our eyes are adapted to perceive and interpret vast amounts of visual information to help us make sense of the world. This becomes problematic for artists, as we must not fall into the habit of letting our eyes convince us that things have such properties as "local color". Local color becomes meaningless compared to the color that is produced when an object interacts with a light source. A face viewed under a traditional tungsten bulb or candle will appear yellow and orange (*fig 37*). When viewed under a fluorescent it will seem full of greens and pinks (*fig 38*). When viewed under overcast light outside, it will be full of subtle greys. So what is the color of a face? It does not matter. What matters is the color of the light source. To execute a painting that is unified and correct, all objects must fall within a plausible lighting condition created by that light source.

The problem comes down to the light spectrum. The sun emits a full, even range of the light spectrum, filling the world with many juicy colors. This can be observed when one takes the easel to go plein air painting-- the outside world is filled with different colors. Inside, however, each type of bulb is only able to clearly illuminate a certain portion of that light spectrum, and it will exaggerate others. With care, you should be able to observe possible colors in various lighting conditions, including sunlight, north light, and various interior lightings.

So how does this help us solve problems? Just like the tools of drawing and color presented earlier, this should be a sort of checks and balances. If the color of your painting is looking inappropriate, out of place, or too grotesque or saturated, it very well might be out of place with the lighting condition you are attempting to render. Remember, the only truth about color harmony is that to look "correct," all colors must fall into the possible range of the light source.

It may be difficult to notice at first. As mentioned earlier, our eyes will readjust and work with our brains to adjust and filter the light to tell us what the "correct local color" of an object is, so we, as humans, will know an apple is red no matter what light it is under. Break away from that thinking, and consider the light source. An apple under incandescent light might be orange, under fluorescent it might be pink, and under north light it might be greys and purples.

Luckily, the same issues of perception that challenge us as artists helps us to fool the

viewer. This is where we can create **powerful** realities: *If you paint everything else in the correct context with the apple, the viewer will perceive the apple as red, even if it is painted orange or pink.*

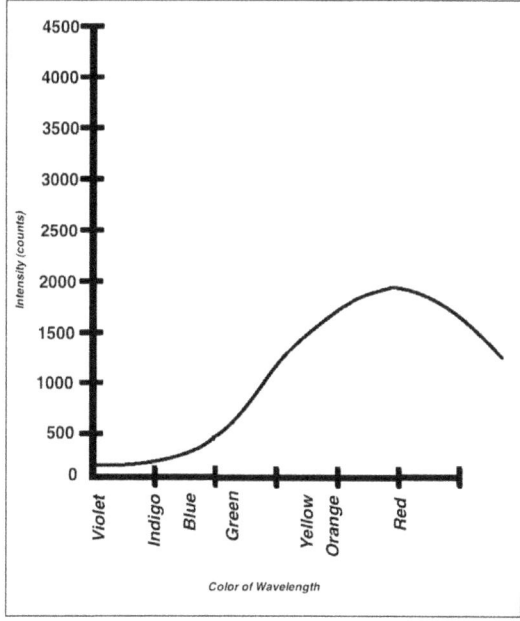

Fig 37. *Color Spectrum of Tungsten Bulb.* **Tungsten bulbs are in the yellow to red range, similar to candles.**

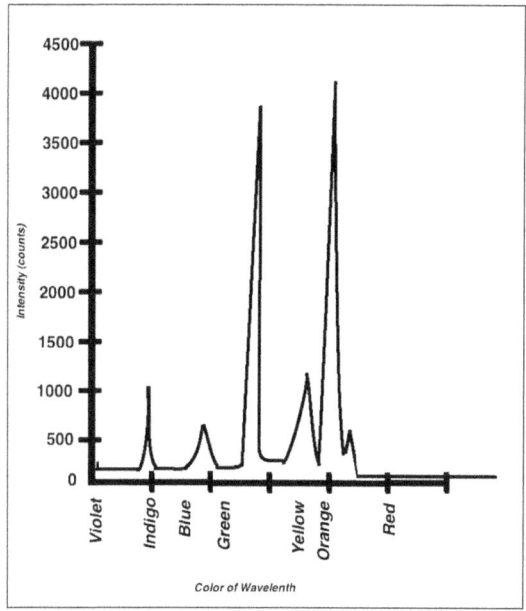

Fig 38. *Color Spectrum of Fluorescent Bulb.* **Colors spike in the warmer greens and between the orange-red range (often appearing as pinks).**

IV. Canvas Lighting

The problem of light is not limited to our subject, but extends to our canvas and palette as well. Certain types of illumination, we have noted, will affect our ability to see certain colors clearly. Aside from the types of light sources, we must also concern ourselves with *temperature*. Any given light will have a temperature, measured in Kelvins. Temperature will indicate how warm or cool the light source appears. The lower the temperature, the more yellow or warm the light will appear. The higher the temperature, the cooler the bulb will appear. Many interior lights that appear yellow are in the 2700-3500 degree range, while bulbs more blue in appearance will reach 5500-6500 degrees. Overcast and north light fall between 5700 and 6500 degrees.

Knowledge of the temperature of the bulb illuminating your canvas becomes imperative for this reason: *The colors you have painted will look different under varying temperature light sources.*

For example, let us assume we have executed a painting under cool natural north light. Your colors will be rich and can cover a beautiful subtle range. Let us take the same painting and place in under a hot halogen spotlight, which is often used in the gallery setting. First, the color temperature of these bulbs is often warmer, casting a blanket of yellow or orange over the piece. Secondly, because the spectrum of artificial light is limited, not all colors are revealed at the same intensity. The painting might at best look unified with warm tones, and at worse lose all color that made it so beautiful. Some galleries are beginning to switch to LED bulbs, which produce a cleaner more balanced white, and are shocked to notice beautiful subtleties that had gone unnoticed.

Let's look at another example: a painting executed under a bulb of warm color temperature. The orange light will have the same unifying effect on your painting mentioned earlier, but when placed under more balanced light, it is possible the colors used are overly emphasized or just plain wrong. Because the spectrum of artificial light was limited, the errors on the canvas were masked while working.

What should you take away from this? *Be aware of the type/temperature of light on your canvas to ensure you are painting colors correctly.* You don't have to paint your paintings under warm light so they look as they would in a gallery or where they will ultimately hang, but every so often you might want to check your painting under these lighting conditions to make sure there are no awkward arrangements of color.

Another thing worth mentioning is the *volume of light on your canvas*. Having less light on the canvas will often encourage an artist to paint values lighter to be able to see them while working, but when the canvas is brought into more light, the colors are overly light and washed out. The opposite is true for too much light. Intense direct light on the canvas while working (such as plein air painting without an umbrella), will produce darker mixtures, because they *look* bright on the canvas while working. Taking the piece indoors to more comfortable light volumes will cause the painting to look too dark. *Always be aware of the volume of light to ensure values are rendered appropriately.*

V. Painting up to the Illumination

Issues will arise when you attempting to paint subjects that are under very bright illumination. It is unwise to place the canvas under this same intense illumination, as the colors will be altered when viewed under normal conditions. This will typically occur when painting bright landscapes, in a studio situation with intense chiaroscuro lighting, or painting an object that itself is emitting light.

Many students will begin to struggle when they see the brightness of the object they wish to paint, and interpret it strictly into a value change. They inevitably attempt to solve this problem with a single solution: adding white paint. What they soon find, however, is that adding white paint, while raising the value, will still never push their painting to the same level of brightness. At best, they will get a light value of a color (generally pastel looking) that can pass as the correct value without the brightness; and at worst, they will get muddy values that destroy the painting. Adding white can alter the color temperature relationship, creating muddy values. Why is this?

There are a couple reasons.

> 1. Unless your canvas and palette are in the same lighting as the subject, it is *physically impossible* to get your painting to be illuminated at the same level as the subject. No color you can mix or apply will create that illumination. So don't bother. The goal is to create the *illusion* of the brightness you see.
>
> 2. Brightness, or illumination, is a combination of not just value, but value and (more importantly) color relationships. You must raise the value of your paint, but *never so much that you are unable to capture the correct color saturation and temperature relationships between the lights and darks of your subject.*

Let's consider an example: a white sphere with an intensely bright yellow light (such as the sun). If the brightest bright in your subject is warm, there is a limit to how much you can raise the value of the paint and retain a warm color. Remember, white is cool, so adding white to a warm color will cool it off. Bring the value of this light side of the sphere as high as possible while retaining the temperature. At this point, lay a neutral dark of the correct value on the shadow side. There may be a correct value relationship, but the painting will lack the brightness of your subject. Alter the dark to keep the same value, but *push the color*

temperature opposite of the light side. In this case, push the shadow side cool. The cooler and more saturated the shadow side is pushed (while retaining the same value), the brighter the light side will look!

Your painting will not be as physically bright as your subject, but you will have created the illusion of illumination!

The painting on the cover, *Minita's Rest,* describes a figure under a fairly bright north light, one much brighter than the canvas should be placed in. The challenge becomes making the figure have the correct skin tone (a darker value) but still appear bright, while also having the clothes appear bright and full of light. While I was working, the painting did not have the *physical* brightness of the model, so I needed to pay special attention to the color saturation and temperature relationships to keep the painting bright without washing it out with white. After all, the painting, when viewed in black and white, falls in the mid value range.

TIPS***

- If you are certain your value relationships are accurate but your painting still looks flat or dull, check your color temperature relationships.
- If you need to raise the brightness, don't just add white.
- Use of light spill (adding a small amount of a shape's color into the surrounding atmosphere) can enhance the look of a very bright light, but should only be used when observed.

VI. Reflected Light

When painting subjects indoors, the size of a room will alter how clean and dramatic cast and form shadows are. As light is emitted from its source, it will travel, reflect off objects, travel more, reflect, travel, reflect, and so on until the last remaining light has been absorbed (similar to how light interacts with pigment). The smaller the room, the more opportunity the light has to bounce off walls and back into the subject (*fig 39*), especially if the wall is painted any color other than a flat black.

This can become complicated when the same temperature of the light source is reflected into shadows (a cool light source with cool light reflected into the shadows). Objects will look less round and less juicy. This is not to say it cannot be painted realistically. On the contrary, a painting executed perfectly can accurately describe a dozen light sources, as well as the size and shape of the room the subject was painted in. It just becomes *more complicated*.

To create a strong, impactful design, have a simple, clear light source with minimal light reflected back into the shadows. A Caravaggio or a Rembrandt is a perfect example of this. Unfortunately, it is impossible to create the drama of a Caravaggio painting without a sizeable studio, or at least a little bit of modification to your current studio.

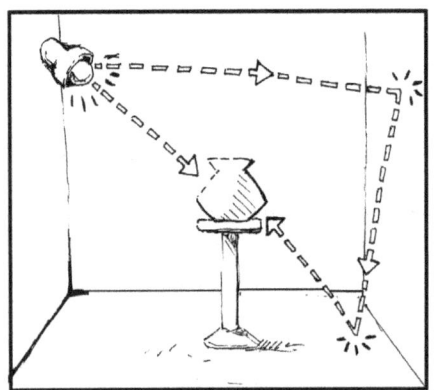 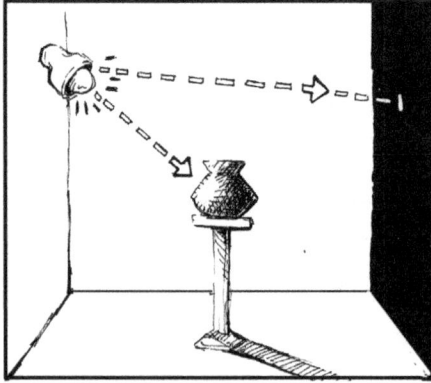

Fig 39. (*Left*) Light bouncing off light value wall of a small room and reflecting into shadow side. (*Right*) light bouncing off dark value wall in a small room and terminating.

TIPS***

- Paint the walls a flat dark color or hang fabric (whatever color/temperature you don't mind reflecting back into the shadows).
- Check all other light spilling onto the subject (this can come from anywhere, including the light used to light your canvas).
- Check the reflected light coming from the floor (this can create unpleasant under-lighting) and add fabric as needed.
- Remember, the darker the shadows desired, the darker the wall or fabric should be.

VII. Lighting Effects on the Canvas

As any artist will tell you, lighting will be your best friend and your biggest challenge. It gives us the beautiful colors we see, but we must overcome the problems it causes on our canvas.

Glare. Paintings, when wet, are highly glossy and will create glare. One of the worst things that can happen halfway through working is to realize the largest spot of glare is in the area you are trying to paint. To help eliminate this, put a wash of mineral spirits or medium on your canvas while setting up. While the canvas is glossy, you should be able to spot any areas of glare, and adjust your canvas accordingly. When the light source is from above, this usually means tilting your canvas so it is angled a little toward the ground.

Canvas Weave. For those opting for more tooth in a canvas, weave can produce an issue similar to glare. Areas painted thinly, without enough paint to fill the tooth, will catch more light causing the color to appear brighter in value. This makes creating transparent darks more difficult than on a canvas with minimal weave. There are three solutions for this problem. The first is to adjust the display light. If you have complete control over where the painting hangs, it will be a small matter to rearrange the directions of the spotlights to ensure the darks don't pick up too much light. The second is to paint thicker in the darks to fill in the weave. If you still want to retain transparency in the darks under all lighting conditions, the final solution is to switch canvas.

Optical Blue. Optical blue is a phenomenon occurring when a brightly lit, light value shape is adjacent to a very dark value shape. The viewer will observe a blue line, glow, or haze in the dark field around the light shape. This is an interesting lighting effect to capture while painting, but it can also appear on the painting, causing the artist to misjudge colors. Optical blue does slightly raise the value in your darks, so they may not appear to be the richest they can be. Before adding more piles of dark paint, isolate your dark color notes from your light color notes to ensure optical blue has not affected your judgment. It is worth noting that this phenomenon can occur in black and white paintings and drawings as well, as it is a product of the vibration of two values, not colors.

VIII. Light in the Shadows

Although how to control reflected light and how to minimize too much shadow fill was discussed, it is essential to stress the importance of light within shadows, even dark shadows.

Shadows should never be painted black. For those who have taken any painting classes, it's one of the first things they tell you (or should). But rarely does anyone explain why.

It starts back again with our discussion on Impressionism. They discovered how to paint light. Amidst their discovery, they discovered that light is everywhere. That's right, EVERYWHERE. Light trickles, spills, permeates, and reflects. Unbeknownst to us, it shoots across the world, across the galaxy, across the universe, even if we are unaware of it. Even if it is the smallest amount of light, it is there (with perhaps the exception of a black hole). The Impressionists learned to see the light, even in the shadows

Prior to the Impressionists, shadows could be painted black, as we hadn't realized this. But, as Parkhurst laments in *The Painter in Oil*, "It is not right now. You cannot go back of your century. To be born too late is more fatal than to be born too soon." His statement is true for all painters– we cannot unlearn what we have collectively discovered. We cannot undo our knowledge of perspective. We cannot disregard the use of value to turn form. And we cannot forget there is light in shadows.

So seek out the light– both in drawing and in painting. *Shadows may be brighter than you once thought.* A mid-gray value, for example, is most likely dark enough for the shadows of a figure. Again, our eyes will readjust enough for us to see a "full value range" of whatever we are focused on– that means the values of shadows will look different depending on where we look. For a more powerful illusion, disregard what your adjusted eyes tell you and paint things as they truly are.

Fig 40

Plate XXII. *Purple Kimono*, 12x16"

In the example to the left, *fig 40* has shadows painted flat black. They become like a black hole, a dead zone that looks like a cut out in the painting and disrupts the illusion. By contrast, **plate XXII** has shadows painted the appropriate value, closer to a mid gray. This allows the look of light filling the painting to create a greater illusion of form.

TIPS***

- Throughout a painting or drawing, continually look away and let your eyes readjust, then look back at your subject freshly and unfocused.
- Squint down: this will help to make sure you have a correct hierarchy of darks. Once you discover the true value of your darkest dark, it will be easier to keep the rest of the values in check.
- Use a value card! Be certain you have good light on your card, then use a scale (5-10 values). When painting low lighting conditions, a darker backdrop for your scale will keep you from perceiving the darks of your set up as too dark. Page 135 has a formatted value card to copy and print.

IX. Varying Brush Stroke Sizes

A common issue with many beginners (more specifically applied toward any style of painting in which paint strokes are to remain visible to the viewer) is brushwork. The variety in a painting can be destroyed if the size of brush used is too consistent throughout the work. This was mentioned briefly in the section on composition, but here I refer to the stale and static look created when all marks in the background are of equal size and style as the marks in the center of interest. This overabundance of similar strokes has some of the same effects as a photograph lacking a focus– too much detail all over. When we naturally view something, anything in focus has finer details, more shapes. Areas in our peripheral are reduced to larger, less obvious shapes, as they are less important to our immediate actions. Having these same size brush shapes painted into the background can provide for an unrealistic viewing experience.

TIPS***

- Attempt to paint background shapes with a brush large enough to handle the shape in one stroke, as opposed to multiple small marks.
- When deciding on the size of the shapes for the background, focus on the foreground and view the background in your peripheral. Don't focus on the background, as you will perceive more small shapes.
- Avoid blending and smoothing out the background. This will read to the viewer as a large smooth shape. If this is done, the foreground must be treated with even greater refinement and polish.

X. Getting Good Brushwork

This again is more useful for those wishing to incorporate the texture or look of brushwork into the finish of their painting.

One of the most fascinating things about the paintings of the American Impressionists, beginning around the time of Sargent, has been the play of brush strokes in creating a bold, confident work, utilizing the look of the brush to imitate textures and designs. This is one of the biggest struggles students have. This style of brushwork comes from confidence. Confidence comes from practice and knowledge. What then surprises me is how little most beginning artists tend to know their brushes, the very tools they must use to make the marks they desire. Until you are aware of how your mark will look, with the exact amount of paint and medium, before you place it on the canvas, you will never be able to create the confident work that made the works of American Impressionists so lively.

Make a brush stroke chart. What better way to get to know your brushes than a brush stroke chart? With a different panel or canvas for each style and hair of brush, see what marks you can make. First, cover the brush with a normal amount of paint, and make a controlled mark. Repeat, but vary the pressure. Create several different marks in this way, then add a little medium to the paint and repeat. Then add some mineral spirits to the paint and repeat. See how long of a stroke you can get. See how well you can maneuver the brush around and make a controlled fluid mark. Push the brush as far as you can go. When you have filled the chart, label it with the type of brush used, the amount of medium, etc. and keep it on file to use at your disposal. Move on to the next brush, and continue until you have explored the potential of each type of brush in your collection. If you notice you are unable to make a certain type of mark you admire in a painting, it may be time to pick up a few new brushes. This should start to help you build the confidence to produce exacting, exciting brushwork.

Bold, Controlled, or Just Plain Messy. There comes a certain point in a painting when one must decide if they will forfeit the exiting bold brush marks (of the American Impressionists) in exchange for something more tightly rendered (of old European masters), describing detail as opposed to suggesting it. The distinction must be very clear, because there is a limit to the amount of softening, pushing around, or correcting one can do before the painting starts to enter the more rendered field. Paintings left in between the two styles

will look messy, unconfident, and unclear. This is the very reason Sargent would wipe his paintings off if he hadn't laid a section correctly in one pass. He was unwilling to sacrifice the Bravado style.

Don't Lick the Canvas. Nothing destroys the quality of brushwork like licking the canvas. Once a stroke has been placed, you must step back and observe the correctness, not continue to stroke with your brush. Don't worry about softening edges. With oil painting, this can be done hours later. *If every stroke is laid correctly, there will actually be very little need to soften edges, the color notes next to each other will usually read as the correct edgework.* Softening should be reserved for later, after the correctness has been established. Again, DON'T LICK THE CANVAS. If a stroke is not correct, remove it; don't push it further into the painting. By avoiding licking, you will create both stronger brushwork and stronger color.

Mix Well. Be certain to mix thoroughly and load the brush with a color that is *consistent all the way through the brush.* If you pick up a small amount of unintentional color and apply it with your stroke, you will be forced to wipe off the stroke and try again. This will eventually wear down the boldness of your strokes. Get in the habit of mixing thoroughly.

Plate XXIII. *Royal Bouquet,* 8x10"

Note how the textures of this painting (the pot, the plants, and the wall) are all created via brushwork. Licking, or excessive brushstrokes, would have ruined the illusion.

XI. Softening Edges

Much like variety of brushwork, there should be a great variety of edgework in a painting. We explored how edges can lay a hand in movement and focus, so it's important to discuss their variety. Though I am reserved in the amount of "how to" I wish to add, for fear of the text becoming subjective to my methods of working, I have noticed a trend among students to handle all non-sharp edges in a uniform way: taking a brush and repeatedly stroking the canvas along the edge of the shape. This uniformity has the same effect as using the same size brushwork all over a painting.

To add more depth, consider some the following methods (*fig 41*):

1. **Flicking**. For a bold softened edge, drag paint lightly from one shape into the next, allowing the natural variations of the brush hairs to show through.

2. **Soften**. The old faithful– lightly pulling a (clean) brush across the edge of shape, slightly pulling one shape into another.

3. **Broken Edges**. Creating irregularity along the edge of one shape that would typically appear as a straight edge.

4. **Adjacent Strokes**. Adjacent strokes of the same or similar value will appear to have a soft edge.

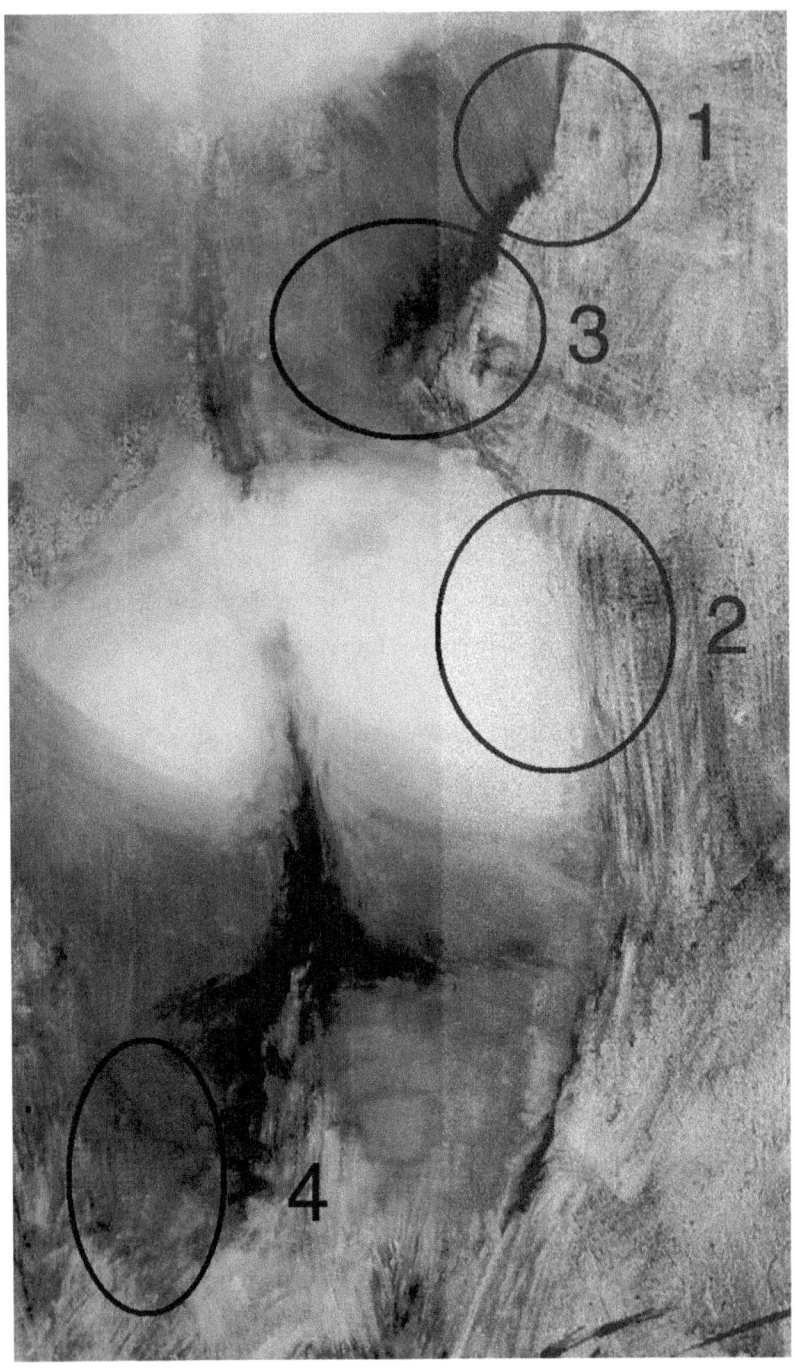

Fig 41

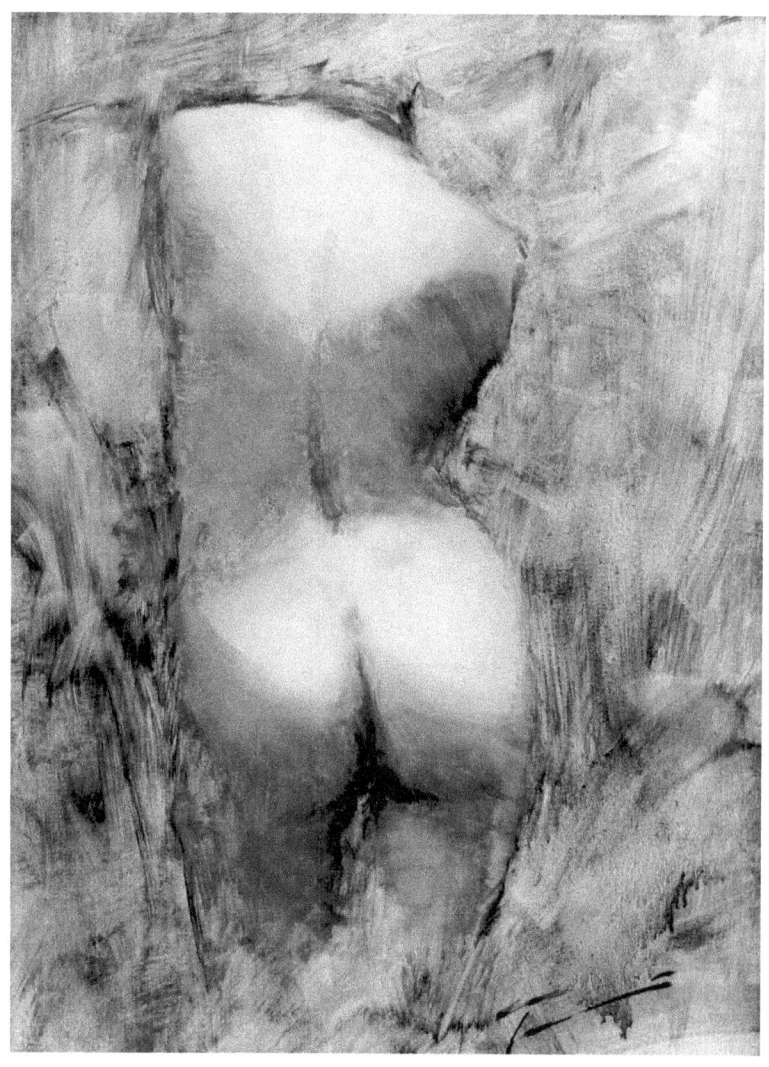

Plate XXIV. *Torso Study II*, 16x12"

I know of no greater masters of edge than Casey Baugh and Jeremy Lipking. Their edgework infuses a sense of reality and romance beyond what any camera can capture, and more delicacy than most could ever see.

XII. Learning to See Things as Brush Strokes

Knowing what brush strokes one can make is good, but translating life as we see it into brush strokes is a whole different story. Uncertainty in a painting leads to pushing paint around and licking the canvas in the hopes that a solution to this translation will be achieved. This will make for weak paintings.

Much like a color isolator helps us to view the color to mix, it is useful to have a method to aid in the approach to brushwork. I devised this method for my students with access to a computer, to help them get the ball rolling (*fig 42-44*):

Fig 42. Take a reference photo of your subject with good resolution.

Fig 43. On a computer, compress the image down to a small file size (10kb or so), then enlarge it to full viewing size.

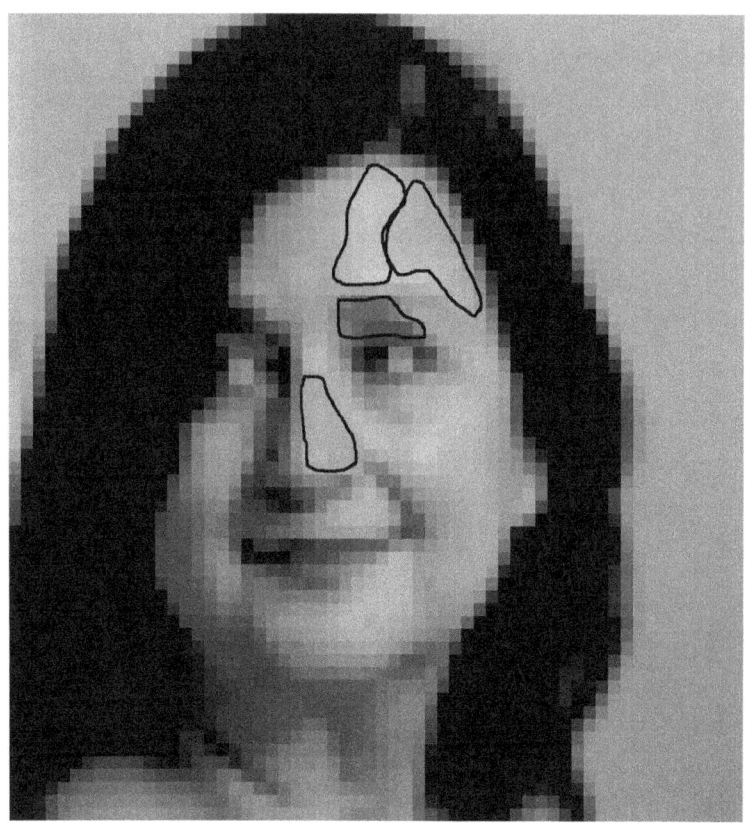

Fig 44. A result of the pixilation will be a reduction of details and a compression of similar value/color areas. From this, trace the shapes made, and their directions. These are your brush strokes. After laying these in, further, more subtle brush strokes can be applied to add more detail or color.

It is important to remember not to use the photo reference for color, as it will be skewed. Work with the image to determine the colored areas of the model that require this compression, or *simplification*, and strive to mix it.

Also keep in mind that this is a technical tool to aid you in learning how to see. Eventually, you should become better and more selective about this simplification than the computer.

XIII. The Dent Effect

Color can be distracting (and as we have discussed, deceiving) to our perception of certain values. While mixing colors of your subject that lay adjacent along the same plane, the values must be close enough to be believable. If the values are misjudged when laid on the canvas, you may very well get *the dent effect*.

Most noticeable on faces and figures, the dent effect is when, in an attempt to alter the color of flesh (for example to get the look of rosy cheeks on a face), the value is altered a bit too drastically. This may go unnoticed to the artist or untrained eye, but it can result in an eyesore that has the subject look as though it is dented or bulbous.

In reality, it is a drawing issue. When attempting to render a smooth surface, the value must be fairly consistent from one side to the other. Change an area within the surface too much, and it no longer looks smooth.

The trouble arrives when the artist is not yet experienced with judging the values of colors accurately. Don't feel bad if this happens; every beginning painter I have met has encountered this issue. There are two steps to isolate and take care of this issue, and even as one grows in skill, these steps are advisable.

>1. Photograph or scan the painting, then convert the image to black and white. This eliminates our perception of color and determines if, and where, the dent effect is taking place. Check for areas in which the value seems too far out of place. Attempt to correct the issue by laying a color of correct value on top of the "dent".

>2. Gain more skill with color. Color sketches, color charts, and the act of painting will slowly train the eye to see and interpret color, and the value of colors, correctly. Be *active* in your pursuit of this advancement, and never be satisfied with haphazard color.

XIV. The Dirt/Bruise Effect

Similar to the dent effect, the bruise/dirt effect can cause an unpleasant look in your subject, especially faces. When *color temperatures are inaccurate, it will look as though your subject has dirt or bruises on the surface.*

Unlike the dent effect, this is purely a color issue, and can occur even if values are accurate. Therefore, the approach to observing/solving the problem is altered.

1. If you or others around you have not noticed anything out of the ordinary, take a photo. Most cameras (of non professional quality) will attempt to create vibrant photos by pushing the saturation of colors, making incorrect color temperatures very obvious. Consider the temperature of the light source, and reapply the correct temperature and color over the "dirt" or "bruise".

2. Gain more skill with color. Again, the better you are able to both see and lay down color, the less chance of this occurring in the first place. If you see the correct color and paint the correct color, you will need to give little thought to correct temperature relationships.

XV. A Note About Historical Palettes

I often have students excited about using historical palettes-- those of old masters. The most common palettes brought up have been those of Velasquez, Rembrandt, and those of American painters around the late 1800's, such as Sargent.

While this knowledge and practice is invaluable, remember that the palettes they used were quite specific to the type of painting they were doing and the lighting conditions they observed.

For example, a student may discover the painter Harold Speed used Yellow Ochre, Burnt Sienna, and Indian Red for a portrait painting. They should also keep in mind that this was a portrait painting completed inside, most likely under a warm lamp. Therefore, the pigment selection was made after an observation of the light source interacting with the flesh color of the model. To have success with this palette, it is advisable to construct a painting under similar lighting conditions. If one were to paint this same model outdoors in an overcast situation, this would be an inappropriate palette selection. I have had much experience with students attempting to fit a square peg into a round hole, as it were.

XI. It's All About Relationships: the Hierarchy

Everything in painting and drawing– everything discussed so far and what you will discover on your own– can all be broken down to one word: relationships.

The world is filled with endless colors and vast amounts of light, both visible and unperceivable. Therefore, it is impossible to paint a literal translation of what is perceived all the time. Painting is a *two dimensional interpretation of a three dimensional world.*

When all else fails, consider the relationships!

A shape cannot look light if there is no dark next to it. An edge won't look soft enough if there is no hard edge against which to compare it. A brush stroke does not look big if there is no small brush stroke next to it. It is the delicate balance of all the relationships that creates a sense of realism.

How can this help? If you relate all shapes, colors, edges, and values back to the same reference brush stroke (or a small group of strokes) in your painting, you can compare the relationship and adjust as needed. The initial brush stroke doesn't even need to be exactly the same value, color, or edge as that corresponding shape in the subject. If everything is related correctly, your painting, while perhaps being different from your subject, will look correct!

Fig 45

1. Initial brush stroke laid in for the forehead.
2. Completed painting relating every judgment of shape, value, edge, and color back to the original stroke.
3. If initial shape was laid in a value darker, provided values retains the correct relationship to the original shape, the painting will look accurate, just darker.
4. If initial shape was laid in wider, all measurements made to it thereafter could be skewed, resulting in an incorrect painting.

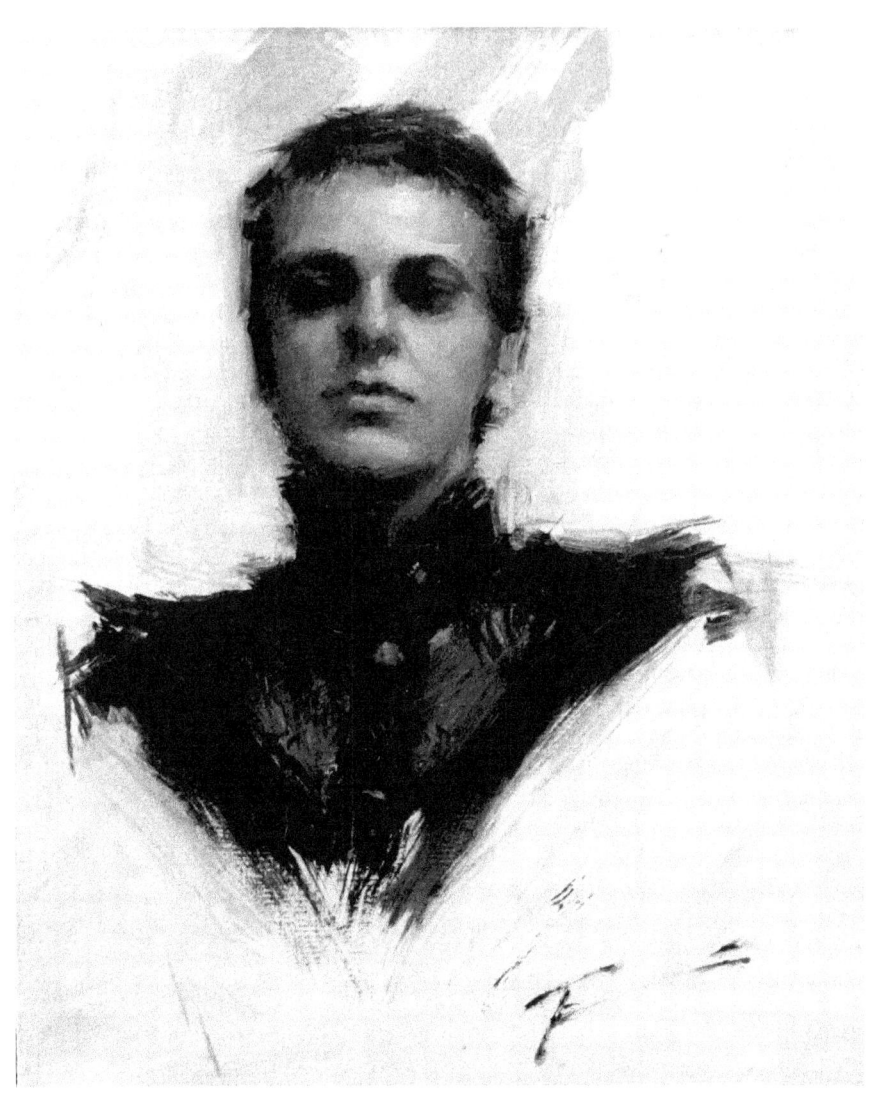

Plate XXV, *The Young Widow*, 12x9"

5. If initial shape was laid in larger, provided all shapes are laid in proportionally correct in size, the painting will be accurate, just larger.

This method works best if the shape of the initial brush stroke is as accurate as possible. If it should be a square, for example, and is placed as a rectangle, the painting could turn out

skewed because too many other shapes are compared to something incorrect *(fig 45-4)*

This is why I encourage students to *spend as long as they need to get this first shape correct*. It becomes the ruler by which to measure all other aspects of the painting. Making a series of approximations can snowball into disaster. Think of that as a copy of a copy of a copy of a copy. Each subsequent shape is a little farther removed from the correctness until in the end the painting may be unsalvageable. Solve this by making the first shape correct, then by comparing everything to it.

Even without starting in this method, the concept of relationships carries great weight. Regardless the approach of a painting, all works must retain a **HIERARCHY OF IMPORTANCE**. This is a straightforward phrase to remind one that a painting is not just a matter of relationships, but of relationships of varying degrees of importance.

For example, one must retain a **hierarchy of importance** when executing edgework. If all edges where hard or soft, they would appear equally important, and the painting would look flat. Determine the most important edges, then be certain, no matter what, all other edges are subordinately sharp. This will bring out the focus, describe the type of illumination, give the viewer information about the forms within the painting, and more. When you start to deviate from the **hierarchy**, you will begin to break down the illusion.

This can be applied to values– pushing the value scale outside the focal point will flatten the painting. Color saturation outside the points of interest will read as points of interest in themselves, disrupting the flow of the painting. Color temperatures not adhering to the hierarchy will cause colors to look muddy. These are just a few examples, and there are countless more. Disruption of this hierarchy will cause a painting to look "off".

One of the most obvious tells of a beginning painter is the failing to observe this hierarchy. Time after time I have had students ask if I will critique a painting they have shown me, and almost inevitably I must start with a question of my own: What is the point of your painting-- what is the focus? Assuming the shapes are correct, these paintings have equal treatment of edges, equal color saturation, equal value distribution, and confused color temperatures across the entire painting. Before I can give advice or suggest changes, I must know *what is important*. What is the point of the painting? That's the top of the hierarchy! Then it's a matter of breaking everything into comparatively less importance.

What can make a painting so much more delicate and beautiful than photographs is that the artist has the power to tell the viewer what is important to them. In the realm of realism, this is the how artists express themselves. Paintings lacking this hierarchy will be at best,

uninteresting, and at worse, look completely wrong or disconcerting.

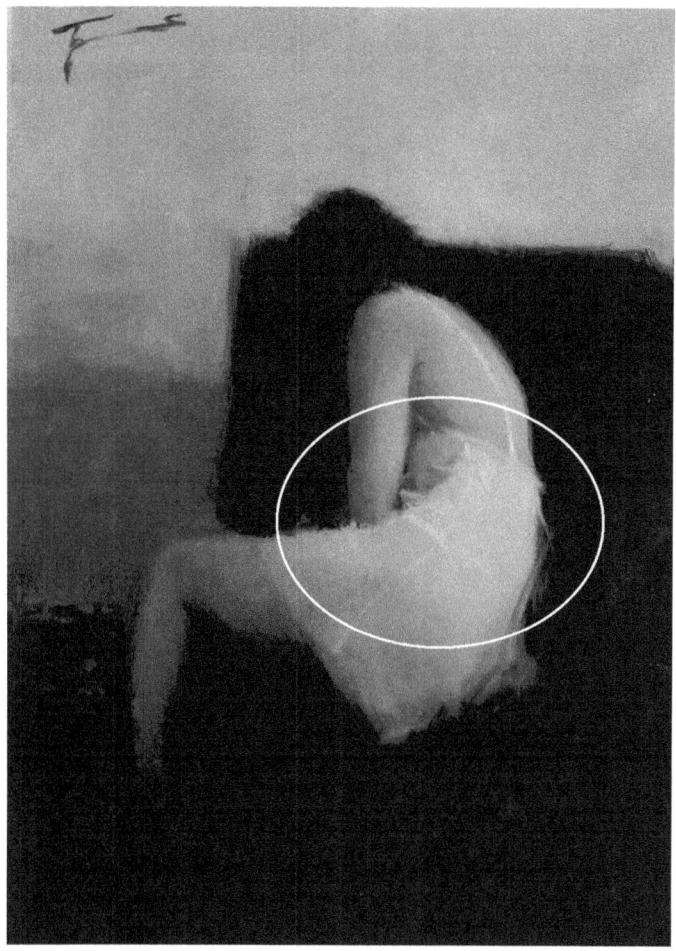

Fig 46. *Area of most importance.* **Edges, details, and value range is most built up in this section.**

In this painting *(fig 46)*, the point is the soft morning light, and how it is striking the figure and bringing out the soft transparency in her nightgown. Though this transparency is impossible to see when reproduced in black and white, it should be obvious that this is the focus of the painting, as it contains the largest value range, sharpest edges, most amount of detail, and smallest brushwork. It is this hierarchy that informs the viewer that the leg or the head is not the subject, and that they should not be looking intently at the wall behind her— the subject is the light on the nightgown.

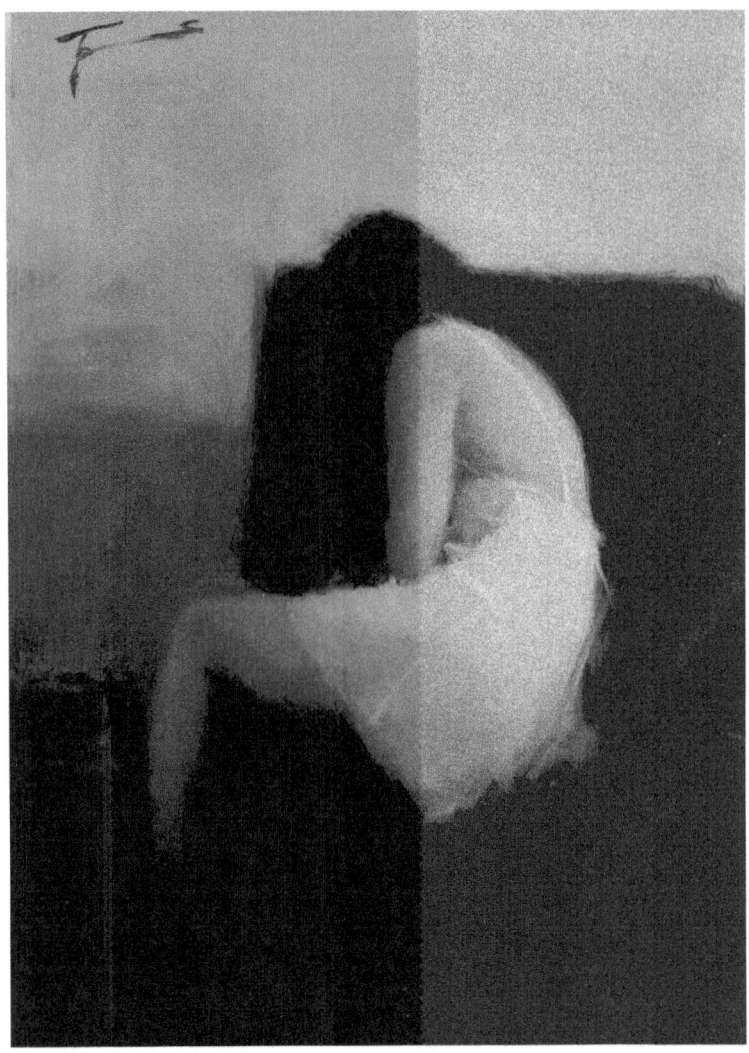

Plate XXVI. *Morning Repose*, 16x12"

TIPS***

- Try to get something you know is correct onto the canvas right away.
- If something looks wrong, compare it back to something you know is right.
- Know where the most extreme ends of the range is for your values, edges, and colors: these are the top of the **hierarchy of importance**
- Never neglect the hierarchy!

A Final Note

Many topics have been presented here, and it takes time to absorb if the material is new. Even understanding a concept rarely translates immediately into one's work. Take time and constantly refer back to the ideas. More importantly, take your own work and run through the list of topics. Are there ways you could have done things differently? Done things better? A painting is a product of the thousands upon thousands of choices made by the artist. Realistic works may be inspired by feeling or impulse, buy they are executed with thought and care. The style of the painting is merely a byproduct of the choices made. Think before you paint, and you'll have less correcting to do in the end.

Recommended Reading

Here is a list of a few good resources, some listed previously for additional references, that can push your understanding of drawing and painting. There are countless amazing things to read out there, but this is a small collection that I seem to go back to again and again while helping students with problems.

Painting Books

All Prima; Everything I know about Painting
 Richard Schmid

Color and Light; A Guide for the Realist Painter
 James Gurney

Classical Painting Atelier
 Juliette Aristides

The Painter in Oil
 Daniel Parkhurst

Compositions of Outdoor Painting
 Edgar Payne

Hawthorne on Painting
 Collected by Mrs. Charles W. Hawthorne

Drawing Books

Henry Yan's Figure Drawing; Techniques and Tips
 Henry Yan

Classical Drawing Atelier
 Juliette Aristides

Charles Bargue and Jean-Leon Gerome: Drawing Couse
 Gerald Ackerman

The Human Figure
 John H. Vanderpoel

Bridgman's Complete Guide to Drawing from Life
 George Bridgman

Online

www.amien.org

gurneyjourney.blogspot.com

underpaintings.blogspot.com

www.artrenewal.org

Recommended Artists

When running into problems, a great solution is to look to the work of others. Over the many centuries of painting, artists have just about done it all. The costumes and buildings may change, but the answers are there. Here's a list of a few artists worth looking into. I attempted to list artists most students are unfamiliar with, followed by those known to the general public, in hopes to lend greater exposure to the amazing breadth of realistic painting.

Historical	Jules Lefebvre	Susan Lyon
William Bouguereau	Alexandre Cabanel	Rose Frantzen
Emile Friant	Frederic Edwin Church	Graydon Parrish
Abbott Thayer	Jean-Baptiste Corot	Clyde Aspevig
John Singer Sargent	Edmund Tarbell	Cesar Santos
Ilya Repin	Cecilia Beaux	Daniel Keys
Isaac Levitan	Mary Cassatt	Dan Gerhartz
Edgar Payne	Edouard Manet	Casey Baugh
Jean-Leon Gerome	Giovanni Tiepolo	Michael Klein
Harold Speed	Andrew Wyeth	David Kassan
Frank Frazetta	Diego Velazquez	Daniel Sprick
Charles Bargue	Frans Hals	Nelson Shanks
Alma-Tadema	Jean-Dominique Ingres	Jeffrey Larson
Anders Zorn	Jacques-Louis David	Robert Lemler
Joaquin Sorolla	Leonardo Da Vinci	Serge Marshennikov
Thomas Eakins	Raphael	Clayton Beck
William Merritt Chase	Michelangelo	James Gurney
John William Godward	Vermeer	Alex Ross
Solomon J. Solomon	Rembrandt van Rijn	Jeffrey Watts
Frederick Leighton	Caravaggio	Jacob Collins
Norman Rockwell	Titian	Scott Waddell
John William Waterhouse	*Contemporary*	Teresa Oaxaca
	Jeremy Lipking	Anthony Ryder
Edward Poynter	Joseph Todorovitch	Burton Silverman
Jules Bastien-Lepage	Richard Schmid	Rob Liberace
Antonio Mancini	Scott Burdick	David Leffel

Copy, print, and laminate this isolator card as a reminder of the 3 aspects of drawing, to compare values, and to isolate colors against black, grey, and white (the back of the card).

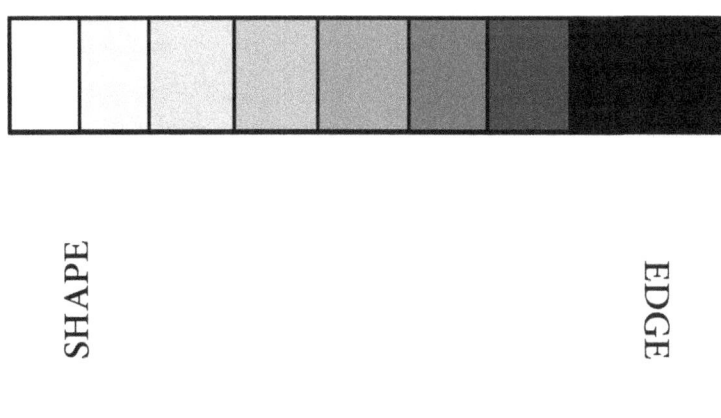

SHAPE

EDGE

CHECK YOUR DRAWING

CHECK YOUR COLOR

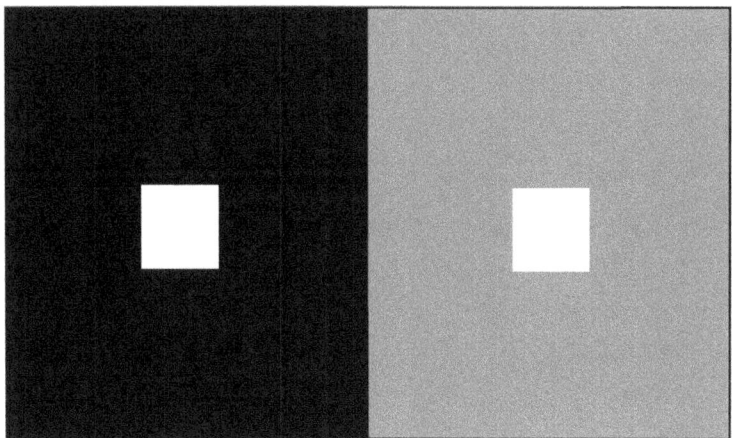

Index of Plates

I.	*The Roman Breakfast*, 33
II.	*Phoenix Rising*, 35
III.	*Her Blue Flowers*, 37
IV.	*The Great Gera*, 39
V.	*Seated Model*, 41
VI.	*The Orange Dress*, 45
VII.	*The Chicago Sewing Machine*, 47
VIII.	*The Old Apothecary*, 49
IX.	*Concerto in the Park*, 51
X.	*Portrait of a Garlic*, 53
XI.	*Mother's Day Bouquet*, 55
XII.	*Figure Sketch (detail)*, 59
XIII.	*Catching the Light*, 60
XIV.	*Portrait of Dan*, 62
XV.	*Misrek*, 64
XVI.	*Brittany*, 65
XVII.	*Still Life from the Farmers Market*, 67
XVIII.	*Melissa*, 89
XIX.	*Copy after Friant*, 92
XX.	*Carnation Falling*, 98
XXI.	*Autumn Bouquet*, 99
XXII.	*Purple Kimono*, 112
XXIII.	*Royal Bouquet*, 116
XXIV.	*Torso Study II*, 119
XXV.	*The Young Widow*, 127
XXVI.	*Morning Repose*, 130
Cover	*Minita's Rest*

Labor Omnia Vincit
Hard work conquers all

www.ingramcontent.com/pod-product-compliance
Lightning Source LLC
Chambersburg PA
CBHW061511180526
45171CB00001B/135